WHALING

ON

Martha's Vineyard

WHALING

ON

Martha's Vineyard

THOMAS DRESSER | *Foreword by Mark Alan Lovewell*

THE
History
PRESS

Published by The History Press
Charleston, SC
www.historypress.net

Front cover, top: Chasing a whale, sketch by a whaleman aboard the *Iris*. *Courtesy of the Martha's Vineyard Museum.*
Front cover, bottom: *Charles W. Morgan* under sail to the Vineyard, 2014. *Courtesy of the* Vineyard Gazette; *photograph by Ivy Ashe.*
Back cover, top to bottom: The *Wanderer*, lost off Cuttyhunk in 1924. *Courtesy of the Martha's Vineyard Museum*; Halyards of the *Charles W. Morgan. Courtesy of Mystic Seaport; photograph by Joyce Dresser*; Whaleboat at sea. *Courtesy of the Martha's Vineyard Museum.*

First published 2018

ISBN 9781540233639

Library of Congress Control Number: 2017963928

To Joyce, my soul mate and partner for more than twenty years.
Thank you for sharing your life and your island with me.

CONTENTS

FOREWORD

We all love whales. To see one swimming in the waters off Martha's Vineyard is a treasure, a wonderful experience.

In September 2009, we watched a juvenile humpback whale make its way through Edgartown's inner harbor. We were worried the twenty-plus-foot baby was in trouble, but that didn't happen. The large animal found its way out, avoiding the sandbars, the mooring lines and the many docks. For years we've retold the story, reinterpreting the significance.

Imagine, a baby whale swims into the harbor where, in the 1800s, whale ships that had traveled the globe used to come in and unload their oil. What would the great-grandparents of this whale have thought?

I have a favorite memory of seeing a sperm whale spout in the waters of Georges Bank, many miles east of Nantucket. I was so touched, a tear clung to the edge of my eye. Whales are returning.

We want more whales around us today, and we know so much more about them than we did a century ago. The story of the whale and this island community is bigger than one generation, bigger than our cultural age and our presence here. The story is bigger than our concern for our coastal environment. And the story of our pursuit of whales alone is beyond measure.

Whales and their migration across the seas of the world were a part of the lives of this ancient island coastal community, a relationship that goes back before us. To pursue the whale, these navigators paid attention.

I, along with others, am a descendant of whalemen, and I have many friends who share in that living tale. Our story and our connection to this place is colored by that distant reach, how far those sailors went to pursue their catch. The blood and might of both men and whale are caught in the mystery and magic of their chase. These Vineyard captains and their crews helped build America. Their labors forged this country's young infrastructure. Whalemen's efforts underwrote the cost of the expansion of the railroad heading west. And their handwritten notes on their navigational charts helped document the extent of vast areas of ocean.

Whaling was intertwined, touching every facet of life on the Vineyard, from the great farming land of the Vineyard to the dockside shanty. In West Tisbury, you can connect today to whaling, taking a walk on the long and winding Dr. Daniel Fisher Road, where goods were brought to Edgartown to be used in readying a ship for a whaling journey. There were whaling captains in Vineyard Haven. Or look to the Gay Head Lighthouse, which was a sentinel for the start or end of a New Bedford whaling ship's voyage.

So I am especially connected to the story of whales and whaling. I welcome with extended arms Tom Dresser's efforts to share the whaling story. It is an old story, but it is also a new story.

For in our changing world, the value and perspective of looking back through time increase. We all could use a better understanding of where this island's residents have gone, to understand the gifts they've left behind.

I feel it when I sit in a relative's Chappaquiddick home that once belonged to a celebrated whaling captain, where one of the cutting tools of whaling hangs on the wall. I feel it when I look through the many collected items in the Martha's Vineyard Museum.

There is relevance in sharing the stories today as we treasure newer ways to appreciate this island, our planet and its finite gifts. Today, we know so many new limits to what our forebears shared.

The giant Edgartown Whaling church, with its clock tower rising over my community, is a significant mark in our history. I can't walk past those tall columns without thinking for a moment of those builders. I can't sit in a pew without thinking of those who filled the church on Sundays and at Christmastime so many years ago. They must have had a far greater apprehension of the deep sea and whales and their men's pursuit of whales.

When fathers and sons went to sea, mothers, siblings, relatives and friends were left behind. No one on the land knew how long those sailors would be away. In today's terms, those sailors could be going to Mars.

So much beyond these waters was unknown. The earth and its oceans, the weather and the ocean's bounty were far less understood. Spirituality and devotion to church was how they must have made sense of it all, along with all the other big challenges of their day.

We treasure their story, for we behold those who hunted for whales and those related to them in our fabric. We already know the pursuit influenced this community in subtle and not so subtle ways. This little island off the coast of Massachusetts was a worldly place, more worldly than some of the more cosmopolitan inland places in that day. Sailors and sea captains who lived here were travelers, having ventured far off to pursue their catch. That meant that when they returned home, there were more stories to be shared.

Being a worldly place meant we were open to afar, open to sailors from every place, open to the value of friendship, lifesaving friendships. The sailors on ships at sea knew more about the value of connecting dots, racial, cultural and about the human spirit.

I am certain that one of the reasons this place feels like home to so many and is sought after by friends from afar is our history of welcome. We have a long history of watching visitors and our residents go down to meet the boat, whether back when it was a square-rigged whaleship returning after a three-year sail or a modern diesel-powered ferry returning after a forty-five-minute trip.

It only takes half a day to fly from here to places that would have taken a year or more on a whaleship. The meanings associated with distant sailing, the value of whales, the environmental part of our connection to our planet have all been rewritten. Whaling is a different story today than it was a century ago—not because of changes in them but in us.

I like to sing old sea chanteys, especially songs that were sung by long gone whalemen. By feeling closer to whalemen, I feel closer to my island and the soil under my feet and especially the ocean lapping on the craft I sail. I think we all feel a need to connect, and taking in Tom Dresser's whaling story should be part of our journey.

MARK ALAN LOVEWELL

ACKNOWLEDGEMENTS

U sually, the author thanks those people who helped him write his book. I'll get to that. First, I want to commend authors of books that were both informative and influential to my story. I reveled in Edouard Stackpole's *The Sea Hunters*, I constantly referenced Judith Lund's masterpiece and I enjoyed Greg Gibson and Judy Druett's books on sadistic mutinies. And Marc Songini's *The Lost Fleet* was full of detail and revelation.

Beyond the books, I want to thank the following people for their assistance: Chris Baer, Peter O. Bettencourt, Funi Burdick, Joyce Dresser, Tom Dunlop, Skip Finley, Tommy Fisher, Jerome Gonsalves, Mark Alan Lovewell, Adam Moore, Cathy Pastva, Ray Pearce, Cynthia Riggs, Bill Roman, Chris Scott, Bow Van Riper, Hilary Wall and Timothy Osborn Ware.

My research was conducted extensively from the files of the *Vineyard Gazette*—love their Time Machine—and the archives of the Martha's Vineyard Museum. The staff at both sites are very capable.

I also enjoyed positive experiences visiting the New Bedford Whaling Museum and Mystic Seaport Museum.

And with The History Press I found an excellent collaborative editor in this project: Lia Grabowski was competent, conscientious and caring. Abigail Fleming was a great copyeditor. The History Press team is very supportive. And my marketing agent Dani McGrath rose to new heights.

It's been a good run.

PROLOGUE

The whaling industry thrived from 1700 to 1900. It was a major economic boon to the community of Martha's Vineyard. This work is a historical account of the impact and influence on whaling by the men and women of Martha's Vineyard.

Martha's Vineyard was neither the busiest nor most profitable seaport during the whaling era. However, a great number of able-bodied seamen and whaling captains hailed from the Vineyard. Profits from the whaling industry bolstered the local economy. Whaling wrecks and calamities devastated Vineyard families. Martha's Vineyard was intimately involved in the whaling industry.

This book provides an overview of a distinctly American business. Chasing and capturing whales and plundering them for their blubber evolved into a sophisticated operation on the open ocean. Risks were accepted as the cost of doing business: long years far from home, isolation and loneliness at sea, inadequate diet, occasionally brutal discipline, dangers of storms and ocean travails. This was the life of the whaleman.

In this book, I often refer to whaling concepts such as logs, lays and gams. The log or logbook was the official record of the whaling venture. The lay was the pay for the men who went whaling. A gam was a social visit between two or more whaleships. These terms and others constitute the whaling lexicon.

Several major events affected the whaling industry as a whole. We refer to these incidents repeatedly. During the Civil War, the forceful exercise

of piracy by Confederate raiders on New England whaleships severely depleted the whaling fleet. The Arctic freeze of 1871 was a near-tragic calamity when dozens of whaleships were trapped in Arctic ice; economic losses were staggering. Two mutinies linked to the Vineyard represent the most brutal of whaling experiences: the *Globe* mutiny of 1824 and the *Sharon* mutiny of 1842.

Throughout, I focus on Martha's Vineyard. However, whaling on the Vineyard was intimately tied to the ports of Nantucket and New Bedford.

And we have to acknowledge, as so many people have before, that *Moby-Dick*, Herman Melville's masterpiece, is still at the epicenter of the whaling industry.

Now sit back, and travel back to a uniquely American era on the high seas.

SHORE WHALING

At best, our vocation amounts to a butchering sort of business; and that when actively engaged therein, we are surrounded by all manner of defilements. Butchers we are, that is true.[1]

Local Native Americans, the Wampanoag, numbered approximately three thousand when the first white man sailed by Martha's Vineyard in 1602. The natives hunted and harvested whales, primarily those that washed up along the Vineyard shores.

The origin of whaling, according to the Wampanoag, is that their legendary ancestor Moshup dove off the Gay Head cliffs and, swimming far out to sea, caught a whale by the tail and dragged it back to the Vineyard shore. He stood on the beach, swinging the whale around his head before dashing it against the clay cliffs. The blood from the whale turned the cliffs a deep, dark red.

Moshup encouraged the Wampanoag to cut the trees on Gay Head to fuel fires to cook the whale. And from that, the Wampanoags learned to feast on the meat of the whale. That is why, according to legend, the trees on the peninsula are so sparse. (Conservationists believe the salt air that wafts across Gay Head stunts the trees.)

The Wampanoag followed Moshup's lead and hunted whales in dugout canoes along the shore and carved up those whales that washed ashore. The Wampanoag considered fresh whale meat an important part of their diet, as did Europeans. Native Americans also used the oil of the whale as a skin salve.

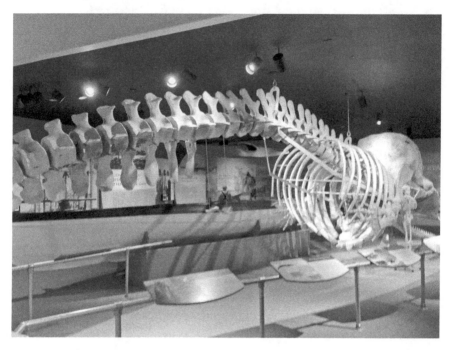

Moshup, the legendary ancestor of the Wampanoag, taught Native Americans about the bounty of whale meat. Pictured here is a whale skeleton in the New Bedford Whaling Museum. *Photo by Thomas Dresser.*

The Wampanoag hunted whales offshore in their dugouts, with spears or harpoons, and harvested whales that had washed ashore. Harpoons that date back six hundred to one thousand years have been found in archaeological digs on Martha's Vineyard.

"The first recorded attempt by white men to kill a whale took place in 1620 while the *Mayflower* was anchored in what was to be called Provincetown Harbor."[2] We don't know how successful that venture was, but we do know the Pilgrims recognized the bounty to be garnered from the sea along the New England coast.

Early white settlers on the Vineyard followed the lead of the Wampanoag in hunting whales. Like the Wampanoag, the white man harvested whales that had washed ashore; this was known as shore whaling or drift whaling. Small huts or houses were constructed along the shoreline to offer shelter for those who watched and waited for a whale to drift by. These primitive shelters offered a place to sleep and held rum against the cold. On the Cape, often several men were stationed in the huts, searching the horizon for a drifting, dying whale.

In 1641, Thomas Mayhew formed the first permanent settlement by the white man on Martha's Vineyard, with the intent of converting the Wampanoag to Christianity. His settlement in Great Harbour, now Edgartown, was by the shore. The ocean was integral to early colonists. One settler, Joshua Barnes, journeyed from England to Yarmouth to Plymouth and eventually settled in Edgartown in 1646. He was a shore whaler, cutting up whales that died at sea and drifted to the shore. Early on, Vineyarders plundered the ocean's greatest mammal, which was relatively easy when a dead carcass washed ashore.

All through the winter, lookouts were stationed along the shoreline, searching for whales. Adjacent to the huts, masts, akin to a crow's nest, offered a better vantage to scan the shoreline. Shore whaling was a relatively simple way to supplement hunting in the fields and forests. In fact, "Records show the prevalence of shore whaling at the Vineyard, and its inhabitants early shared in the marketing of the oil. Lookouts and tryhouses became a part of the landscape."[3] (Try houses were fireplaces where pots were heated to reduce blubber to oil.)

Whale cutters were appointed to carve up or harvest the so-called "drift" whales brought to the shore by the wind or the tide. Regulations were established in Edgartown that drift whales were to be cut freely, meaning the whale meat was to be shared among townsmen. In 1652, Thomas Daggett and William Weeks were appointed whale cutters for the town, responsible for overseeing a fair distribution of the whale meat.

A subsequent town decision affirmed that the cutting-in process of drift whales was shared equitably. "In 1690 Mr. Sarson and William Vinson were appointed by the 'proprietors of the whale' to oversee the cutting and sharing of all whales cast on shore within the bounds of Edgartown."[4] Throughout much of the seventeenth century, shore whaling was the primary means of taking a whale.

Shore whaling proved an important element in the hardscrabble economy of the late 1600s. On occasion, arguments arose over who was entitled to the whale. A whale washed ashore in Edgartown in 1692, and two men both claimed it. When a third man entered the dispute, it was shown his harpoon had killed the whale, so he earned the right to share in the proceeds.

This 1692 case provided precedence in the practice of sharing the proceeds from the contested capture of a whale. A 1793 court case arose when men from two ships harpooned the same whale. The Massachusetts Supreme Judicial Court determined both ships should share in the blubber.

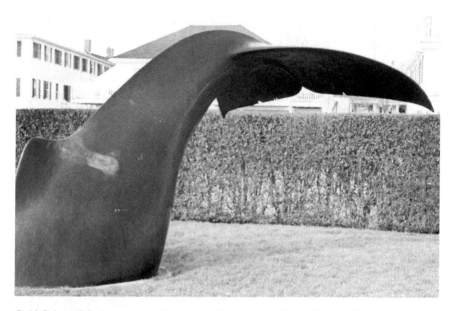

Ovid Osborn Ward, great-grandson of whaling magnate Samuel Osborn Jr., was the sculptor of this iconic whale statue in Edgartown Harbor. *Photo by Joyce Dresser.*

It became accepted practice that whoever's harpoon was found in a captured whale should share in its distribution.

A tax on the oil of drift whales was levied by Plymouth Colony in 1652. One barrel of oil per whale was to be paid to the colonial treasury. And in estates along the shore, whaling items often appeared in the inventory of a decedent, whether as "oyl," "kittells" or harpoons. "It will thus be seen that the Vineyard was among the first of the colonies to make use of the whale as a commercial industry."[5]

No boats were needed, and no spears were thrown—the meat was easily harvested. However, with the increase in the colonial population and the haphazard nature of drift whaling, shore whaling proved too dependent on happenstance or chance.

Fewer laws on shore whaling were enacted after 1725, indicating that the process of whaling was evolving from a land-based to an ocean-based operation. Vineyarders recognized their best chance was to go to sea to capture whales, following their Wampanoag forebears.

The men of Martha's Vineyard set the pace for whaling, capturing whales years before Nantucket was even settled by Europeans.

The original group of Nantucket colonists was known as the First Proprietors. The colonists purchased the island in 1659 from Thomas

Mayhew of Martha's Vineyard for thirty pounds and "two beaver hats, one for myself, and one for my wife." Nantucketers honed their whaling prowess by copying comparable coastal communities, mimicking techniques developed on Cape Cod, Martha's Vineyard and Long Island. In the late seventeenth century, a tower was erected on the shore of Nantucket as a lookout for whales.

The first whalemen set to sea from Martha's Vineyard prior to 1700. John Butler (1650–1738) captured whales offshore and reduced their blubber to oil in his try house, where pots of blubber were boiled down to oil. "Prior to 1700, he [Butler] carried on whaling in the shoals and kept his try house busy. An Edgartown record shows Butler to have made several catches between 1702–3."[6] Besides Butler's try house in Edgartown, another was erected in Holmes Hole, now Vineyard Haven, in the early 1700s.

An authority on the early history of whaling, Alexander Starbuck, asserted that "it is quite probable that deep-sea whaling did not commence at the Vineyard until about the year 1738." Starbuck reported that Joseph Chase, from Nantucket, "purchased a house and about 20 acres of land on the shores of Edgartown Harbor, erected a wharf with a try-house near, and commenced the fishery with his vessel."[7] Prior to 1750, three different Vineyard men ventured in whaling at sea for a couple of years but did not find it financially remunerative.

Candles were first manufactured from sperm oil by Benjamin Crabb of Rehoboth beginning in 1749. Crabb's experiment used spermaceti bailed from the head of a sperm whale. Spermaceti candles burned with a cleaner, brighter light than wax candles. The success of these candles, using spermaceti oil, inspired efforts to capture sperm whales.

As whale oil became more valuable, whaling expanded rapidly. More whaleships were built, manned and launched. The protocol for chasing whales was established early on. Small whaleboats were lowered into the water from the whaleship and rowed off to chase a whale. The harpoon, or lance, affixed to a lengthy line, would be thrown into the side of a whale or back of its head; a second harpoon was thrown for the kill. This system was in use for more than a century.

Aboard ship, life proved both lonely and dangerous. For the crew, living within the confines aboard a vessel over a long period of time was difficult, as whaleships traveled far offshore to chase whales. As the North Atlantic became overfished, ships sailed farther from their homeports.

Whaling could be dangerous. At least three instances were reported of a man caught in the mouth of a whale. In the late 1700s, one Marshall Jenkins survived, but he was scarred for life.

Whaling could be cruel. When a captain was unable to maintain discipline, he could turn angry, and there was little recourse for the crew. Hiram Fisher of the *Meridian*, out of Edgartown, proved a brutal master. Strict adherence to the line of command was demanded; disobedience led to incarceration in irons or flogging. Punishment was at the whim of the captain, who felt he had to maintain control.

An angry crew aboard a whaleship could spawn an insurrection. If the crew had suffered too much, a mutiny might occur. While it was a rare occurrence, it was not unique. The *Globe* suffered such a mishap when Captain Thomas Worth was murdered at sea; that dramatic saga lives on to this day.

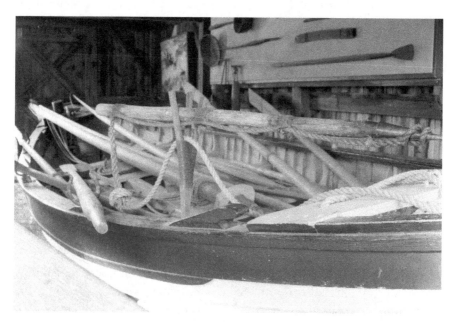

A whaleboat could be rolled over or crushed by the flip of a whale's tail or crunched in a whale's mouth. Pictured here is a whaleboat at Mystic Seaport. *Photo by Joyce Dresser.*

Whaling pushed the boundaries. Edgartown's Captain Peter Pease (1732–1829) of the *Susanna* sailed into the West Indies in 1763. New England whaleships, the *Beaver* from Nantucket and the *Rebecca* from New Bedford, ventured into the Pacific in the 1760s. Captain John Pease of Martha's Vineyard, on the *Chandler Price*, discovered the Nomwin Islands, north of the Carolines, an archipelago of small islands in the northwest Pacific.

Whaleships made it to Greenland in 1746, to the Gulf of St. Lawrence in 1761 and to Brazil by 1774. New Englanders set the pace as whaling gradually expanded around the world. Historian Edouard Stackpole recognized the irony that American whaleships in the nineteenth century were welcomed on islands in the Pacific that fell under the Japanese empire, an enemy to the United States in the mid-twentieth century.

The small seaside community of New Bedford was situated at the western end of Buzzard's Bay. In 1765, Nantucket whaling merchant Joseph Rotch recognized that New Bedford would make a profitable whaling port. It was on the mainland, rather than an island, but had a deep, protected harbor. Rotch moved from Nantucket to New Bedford, and the new arena quickly evolved into a prime site for the nascent whaling industry. Two years later, his first whaling ship, the *Dartmouth*, was launched.

Competition between Nantucket and New Bedford quickly outperformed the Vineyard in the whaling community. By 1770, Nantucket boasted 125 whaleships; New Bedford had 50; Wellfleet, on Cape Cod, sent 20 ships to sea; and Boston had 15 whaleships. Only 12 whalers sailed from Martha's Vineyard.

Although the majority of whaleships called Nantucket or New Bedford their home port, it was often a Vineyard captain and crew who manned the ships. Vineyarders sailed aboard many of the ships that pushed the boundaries of the whaling industry. Captain John Morse of the *Hector*, from New Bedford, had a crew of twenty-seven men. "This was practically an all–Martha's Vineyard crew, and two of the officers, Thomas Norton and George Luce, later became famous whalemen."[8]

On the Vineyard, as in many New England seaside communities, "the young men, with few exceptions, were brought up to some trade necessary to the business. The rope-maker, the cooper, the blacksmith, the

carpenter—in fine, the workmen were either the ship-owners or of their household."[9] While a ship was at sea, the owners prepared supplies for its next trip. The whaling business was always busy.

The coastal location of the islands of Nantucket and Martha's Vineyard was advantageous to whaling. Yet "at the Vineyard a livelihood could be attained from tilling the earth, [while] at Nantucket a large portion of that which sustained life must be wrested from the ocean."[10]

The urgency to go to sea was more acute in Nantucket. The fertile soil of the Vineyard offered an alternative to whaling, while Nantucket had poor soil, so fishing and whaling proliferated. On the Vineyard, it was possible to farm successfully on land enriched by the outwash of the glacial moraine. Vineyarders had more economically advantageous options without the dangers of the sea. Nevertheless, many Vineyarders preferred the challenges of whaling to the drudgery of farming.

Captain Jared Fisher embodied the romantic role of an Edgartown whaling master. Fisher was captain of the *Minerva Smith* and later the *Omega*. Longing for his wife, Desire, he scrolled amorous odes to her in the ship's log. Later, Desire accompanied him aboard the *Navigator*, whaling the Indian Ocean from 1858 to 1862.

"As an experiment in wife-carrying, however, it did not turn out well. Desire was appallingly seasick—so sick, in fact, that Jared had to turn back into the Atlantic after only six months of the voyage."[11] Of Desire, "she yearned for a floor that did not heave or sway, for a lamp that could be put quietly on a table, and for food that a home kitchen could provide."[12] Jared Fisher sent his ailing wife back to Martha's Vineyard ahead of his return in 1862. Shortly thereafter, Captain Fisher sold the *Navigator* and assumed the role of a local merchant.

Jared Fisher's descendants lived in his house until 1961; it is now operated by the Society for the Preservation of New England Antiquities.

Across from the Fisher house at 86 North Water Street in Edgartown was the spermaceti candle factory operated by Dr. Daniel Fisher (no relation). Spermaceti candles proved popular well into the nineteenth century.

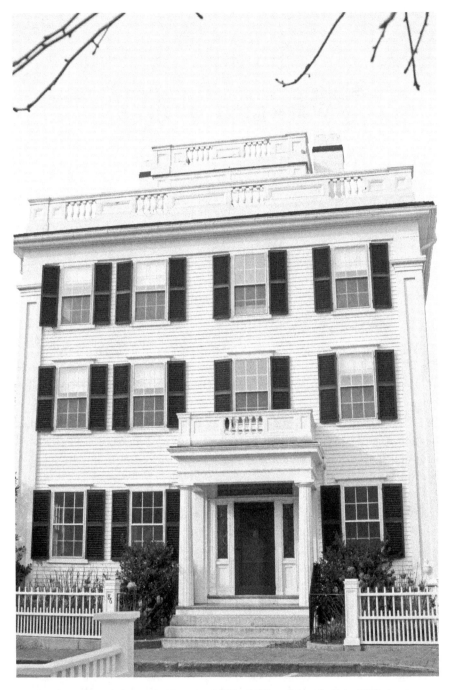

Captain Jared Fisher's impressive home at 86 North Water Street, built in 1832, dominates adjacent mansions with its widow's walk. *Photo by Joyce Dresser.*

2

WHALING PORTS

Of whaling, "New England had founded it; the young colonial towns of the coast had nurtured it."[13]

The three whaleships moored in Boston Harbor in December 1773 gained fame not for their whaling exploits but for another activity altogether. The *Dartmouth*, the *Beaver* and the *Eleanor* sailed from Nantucket to London laden with whale oil. The oil was sold in London, and the three ships were then loaded with tea and returned to Boston to assume their historic role in the Boston Tea Party. The Sons of Liberty, colonists attired as Indians, tossed cases of tea into Boston Harbor rather than pay a tax on tea to Parliament.

On Martha's Vineyard, locals were less dramatic and operated below the radar. A Captain Leonard sailed to London and returned to the Vineyard, where he smuggled ashore a boatload of tea into the basement of his aunt's house on a dirt roadway in Chilmark now known as Tea Lane. Captain Leonard doled out his tea to relatives, neighbors and friends without paying the tax. Savvy Vineyarders enjoyed their tax-free tea.

Whale oil proved an important illuminant on both sides of the Atlantic. Whale oil–fueled streetlights were installed in Boston in 1773. The intent was to reduce criminal activity at night and offer visibility on city streets after dark. Oil was used to make candles. "The original products made from spermaceti wax were primarily candles. They would have been bleached to a snowy white and would have burned with a bright flame with almost no smoke or odor."[14]

Whale oil became a necessity for the nascent nation. "Whale oil was a preferred illuminant throughout the civilized world. It burned cleaner than tallow or vegetable oils, and was relatively easy to extract. It was also in demand as a lubricant, and used in the tanning of leather, the manufacture of soap and paints, and the preparation of wool."[15] And the only way to manufacture whale oil was to continue to launch whaleships into the Atlantic, eventually into the Pacific and finally to the Arctic Ocean to capture the leviathans and produce more oil.

By the time the American Revolution erupted in 1775, whaling had become an economic engine for many New England coastal communities. Although codfishing was popular in Massachusetts, whaling generated more income in the local economy. According to records of Thomas Jefferson in the 1770s, harvesting codfish brought £250,000 sterling per year; while whaling produced some £350,000 per year.

Yet at the time of the Revolution, the Town of Tisbury reported failed whaling voyages, with a minimal market for the oil the whalemen garnered. The whaling industry on the Vineyard fell into decline just prior to the Revolution. The dozen or so active Vineyard whaleships, manned by 150 whalemen, produced only 1,200 barrels of oil annually. The Vineyard slipped far behind competing communities of Nantucket, Dartmouth, New Bedford, Wellfleet and Boston, all of which produced more whale oil than the Vineyard in the 1770s.

When the Revolution began, Nantucket was a Loyalist stronghold, and Martha's Vineyard was neutral. Whalemen from Nantucket felt pressure to continue to hunt for whale but feared reprisals from fellow colonists for their support of Great Britain. Nantucketers "fitted out some twenty sail of ships and brigs" to go whaling in the Falklands, along the South American coast, far from the war. With the Vineyard neutral, Nantucketers housed their fleet of twenty whaleships in Edgartown or Holmes Hole, now Vineyard Haven, prior to setting sail to go whaling.

The Vineyard did not remain neutral. In 1775, Joseph Mayhew of Chilmark was appointed to head "A Committee of Safety for Dukes County" to protect the Vineyard. That fear was justified. In September 1778, the British navy under Admiral Charles Grey burned the fledgling community of New Bedford and then set sail, forty ships strong, for the islands of Martha's Vineyard and Nantucket. The intent was to frighten the residents and commandeer livestock to feed the British army.

The British absconded with sheep from Naushon, in the Elizabeth Islands, then sailed to Holmes Hole to continue marauding on Martha's Vineyard.

"At the Vineyard harbor of Holmes Hole, the raiders' fleet stretched from shore to shore, like a swarm of sea-going locusts." During September 11–12, 1778, British soldiers confiscated more than ten thousand sheep, three hundred cows and oxen, multiple pieces of weaponry and £10,000 sterling. The sheep and cattle were herded down to the harbor and aboard the ships. Grey's Raid devastated the Vineyard economy.

Admiral Grey prepared to leave Martha's Vineyard and sail to Nantucket, regardless of that island's Tory support. Vineyarders watched their departure. "Then occurred a circumstance which was almost miraculous. An east-northeast gale sprang up on the night of September 11."[16] The British fleet was unable to sail against the gale. Sir Charles Grey had to turn back and sail down Vineyard Sound to New York with the Vineyard sheep, leaving Nantucket in the clear.

The whaling industry as a whole collapsed during the Revolution. Shortly after the war, New Bedford briefly surpassed Nantucket in the number of ships sent to sea. Later, between 1787 and 1793, Nantucket refocused and invigorated its whaling industry. Whalemen realized capturing the right whale led to black oil, which proved more refined than sperm oil. "Thus, turning from the sperm to the right whale fishery for a few years, the Americans, led by the Nantucketers, speculated successfully with the Europeans."[17] War slowed the whaling industry, but the rebound proved more successful and expansive than before the war.

A goal of whaling was to promote whale oil to the Europeans. Ambassador John Adams met with Prime Minister William Pitt in August 1785. According to Adams's papers, he claimed spermaceti oil could successfully be sold in European cities that sought nighttime illumination, "as it is so much better and cheaper than the vegetable oil that is commonly used. The fat of the spermaceti whale gives the clearest and most beautiful of any substance that is known in nature, and we are all surprised that you prefer darkness."[18] Adams' sarcasm has not been lost on historians.

Thomas Jefferson, the nation's first secretary of state, issued a report on the whale fishery (1787–90) of New England ports engaged in whaling: Martha's Vineyard, New Bedford, Nantucket and Cape Cod, among others. In 1790, 122 American whaleships were at sea, with a take of

21,100 barrels of oil. Nantucket led all whaling ports in production of barrels of whale oil.

The full title of Thomas Jefferson's dissertation was the "Report of the Secretary of State, on the Subject of the Cod and Whale Fisheries, Made Conformably to an Order of the House of Representatives." Jefferson's document provided a critical assessment of an integral industry in the new nation: "It is important on two levels: first, as the best statistical report on the history and state of the American fisheries and whaling industry; and second, as a partisan political document, in opposition to Alexander Hamilton."[19]

Jefferson recognized that whaling played an important role in the economy of the new nation. He was aware codfishing and whaling were both hindered during the Revolution by government regulation and taxation. Men who depended on the codfish and whaling industries sought redress, first from the Massachusetts legislature, then Congress. Jefferson addressed the impediments caused by government-imposed taxation and regulatory policy.

As secretary of state, Jefferson also acknowledged that British intervention in whaling during the Revolution had negatively impacted the whaling industry. He suggested the federal government should encourage both codfishing and whaling. According to the Gilder Lehrman Institute of

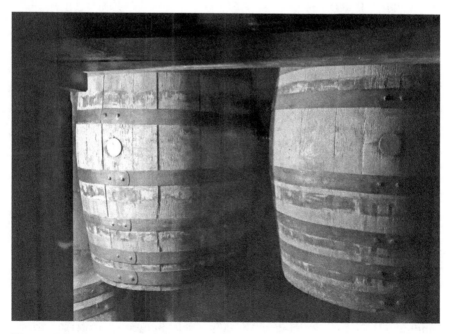

Thomas Jefferson recognized that the bounty from the sea could stimulate the anemic economy of the new nation. *Photo by Joyce Dresser.*

American History, Thomas Jefferson also predicted success in fishing would instigate shipbuilding and associated industries. Jefferson's report spurred Congress to enact legislation to revitalize the whaling and fishing industries.

Actions in the closing years of the eighteenth century stimulated significant success in the whaling industry, especially for Nantucket in its dominant role. Other communities vied for the financial rewards that accompanied successful whaling ventures.

One minor historical note of this era was that the whaleship *Betsey* arrived at Hooapoah, north of the Marquesas, in the Pacific, in 1798. Fifty years later, in 1842, Hooapoah was where Herman Melville and fellow shipmate Tobias Greene deserted the whaleship *Acushnet*. And of course, it was Melville's tome *Moby-Dick*, published in 1851, that captured the spirit and drama of the whaling industry.

"You are undoubtedly aware that the Vineyard was just a minor whaling port compared to Nantucket in the early years and New Bedford in the later years," wrote Timothy Coffin Ward, a great-grandson of Samuel Osborn Jr., a key whaling magnate on Martha's Vineyard. The Vineyard did, however, assume a small but crucial role in the whaling industry throughout the nineteenth century.

The Vineyard played a pivotal part in providing captains and crew for whaleships from Nantucket and New Bedford. The Vineyard "was a nursery of seamen. And in the early years of the next century, Edgartown, or Old-Town as it was affectionately known, became a valuable port of clearance and entry for those Nantucket whaleships, deep-laden, which could not get over the shoal or bar at their home-harbor entrance."[20]

The whaleship *Globe* exemplified this unique relationship between the Vineyard and Nantucket. Like many other whaleships, the *Globe* was registered in Nantucket but outfitted and sailed from Martha's Vineyard. As whaleships were designed to go on longer journeys, they were larger and drew more water. A sandbar at the entrance to Nantucket Harbor prevented ships with a deeper draught from passing over the bar. With deeper whaleships, cargo had to be offloaded prior to approaching the sandbar off Nantucket Harbor. Small vessels, lighters, transferred whale oil or ship's supplies.

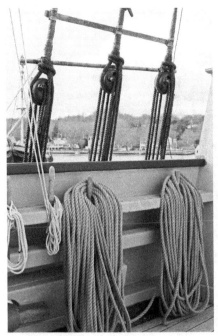

Halyards hoisted the sails up the mast of the whaleship *Charles W. Morgan*. *Courtesy of Mystic Seaport; photos by Joyce Dresser.*

An effort was made to manually raise whaleships over the Nantucket sandbar using inflatable balloons, called camels, which, when filled with water, hoisted the ship over the bar. This system proved inefficient and unreliable.

More often, Nantucket whaleships docked in Edgartown Harbor, offloaded their casks of whale oil onto Morse's Wharf on North Water Street, then returned to Nantucket. Eventually, New Bedford surpassed Nantucket to dominate the whaling industry, in part because of the impeding sandbar.

The Vineyard continued to play a subservient role in the whaling industry. However, by providing capable masters and a spacious harbor to accommodate whaleships, Edgartown served a critical function in the whaling world. Even with the sandbar, Nantucket still imported more oil than competing ports into the late 1820s.

Over a century and a half, nearly fifteen thousand whaleship voyages took place. Whaling was a very viable business. And while the Vineyard participated in the profitable whaling industry, the number of whaleships traveling in and out of Edgartown Harbor was miniscule compared to other ports of entry.

This page: The tryworks held two 250-gallon trypots to reduce whale blubber to whale oil. *Tryworks at Martha's Vineyard Museum, photo by Thomas Dresser, trypot at Mystic Seaport, photo by Joyce Dresser.*

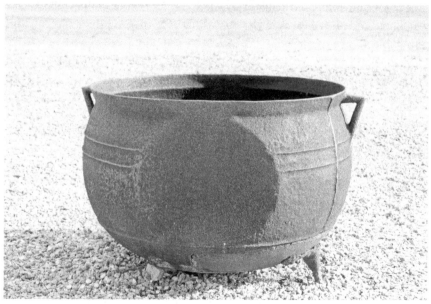

Judith Lund's *Whaling Masters and Whaling Voyages Sailing from American Ports* categorized whaleship sailings from New England communities during the years each port thrived.

PORT	OVERALL TOTALS	DATES
New Bedford	5,146	(1754–1937)
Nantucket	2,223	(1698–1887)
San Francisco	1,171	(1849–1930)
Provincetown	1,156	(1789–1915)
New London	1,116	(1718–1908)
Edgartown	237	(1738–1894)
Falmouth	71	(1768–1864)

In 1938, members of the Works Progress Administration (WPA) compiled the original data of whaling expeditions with the goal of making the information in various whaling documents more accessible. That work "remained a classic, unsurpassed and never superseded."[21]

Lund characterized the success of 14,864 whaling voyages—545 ships were lost, a mere 3 percent. Whaling was dangerous for the captains and crew, yet proved relatively free from serious injuries, death or wrecks. And it certainly was financially remunerative for the owners and investors of the whaleships.

The majority of whaleships were registered to ports other than Martha's Vineyard. Yet Vineyard men served on ships registered in those various ports. Thus the men of Martha's Vineyard were party to the infamous adventures and mishaps in the history of whaling. When one reviews ships sailing from the several ports, invariably a Vineyarder shows up as a member of the crew or captain or played a part in the ship's adventures.

Lund's book also categorized the number of whaling voyages from various Vineyard ports. (Holmes Hole is Tisbury, Oak Bluffs was part of Edgartown and Martha's Vineyard was listed separately from the individual towns.)

Edgartown	237	(1738–1894)
Holmes Hole	37	(1815–1865)
Chilmark	1	(1848–1849)
Tisbury	2	(1867–1870)
Martha's Vineyard	15	(1738–1857)

Captain Nathan Jernegan hailed from historic Vineyard lineage. He sailed the *Niger* on three whaling expeditions in the mid-nineteenth century and was captain of the *Splendid*, from Edgartown, between 1867 and 1872. Jernegan's home was at 68 School Street, Edgartown; his brother Jared, also a whaling captain, lived two blocks away on South Summer Street.

Nathan Jernegan brought his wife, Charlotte, on a whaling expedition in 1856. After four years at sea aboard the *Niger*, Charlotte came ashore wearing a hoopskirt. As she rode in a carriage along New Bedford's cobblestone streets, she noticed the local women were not wearing hoopskirts—they were no longer in fashion. Without hesitation, "[I]t was not long before she emerged again from a round of the shops, so that when she reached the Vineyard she was attired in the height of fashion with a linen suit and pancake hat."[22] Hoopskirts were passé, and Charlotte Jernegan adjusted.

3

WHALING

The love of the whale for its young is great, so that whalers, whenever they can harpoon them, are pretty sure of getting its parent.[23]

W haling was messy, hard, labor-intensive work. It ranged from heroic and harrowing to tedious and tiring. It was lonely and dangerous, and participants were far removed from their families for years on end. There was money to be made—primarily by the ship's mates and master and by the whaleship owners and investors. Able-bodied seamen could expect to work for months, even years, with minimal income. And yet it was a popular career for young men in the nineteenth century on Nantucket, Martha's Vineyard, New Bedford and other New England ports.

The goal was to chase a whale, kill it and harvest the blubber to be boiled down for oil, which was stored in wooden barrels. The barrels or casks were lowered into the hold of the ship, then sold to merchants when the trip was over.

The process was rarely that simple and often entailed potential points of danger. Whether chasing a whale, dragging the leviathan to the whaleship, harvesting the blubber, storing blubber below deck or boiling the blubber in the giant trypots on deck, it was a risky business. That last task was smelly, dirty and dangerous, yet essential.

Henry Acton composed a small tome for his son, William. *A Whaling Captain's Life* was published in 1838 and served as a primer of nineteenth-century whaling, with descriptions of the industry and the dangers and rewards of whaling. Acton approached his topic in a solicitous manner; the book has the feel of a familial chat between father and son, as intended.

Acton opens his discussion with a description of the size of a whale, suggesting a typical whale is about sixty feet, "which implies a weight of 70 tons, being that of 300 fat oxen."[24] In language a young boy of the nineteenth century could grasp, Acton expresses his awe at the wonders of the whale and shares useful information. He notes the tail of the whale is its most mobile limb; with a sudden slap, it can smash a whaleboat and send the crew splashing into the ocean.

Henry Acton described varieties of whales, asserting the razorback (fin whale) is most dangerous and can swim up to twelve miles per hour. It could rapidly get away, even with a harpoon pierced in its skin.

Whalemen identified a sperm whale by its single spout. Sperm whales have jaws with teeth to capture giant squid and devilfish. Blubber keeps whales warm, as they are mammals, not fish. The oil from sperm whales produced the best lighting.

A bowhead whale has two spouts. The mouths of bowhead and right whales have sieves for straining food. The sieves are baleen, which is flexible like plastic. Baleen was used in corsets, scrimshaw and stays. Like bowheads, right whales have baleen instead of teeth. Blackfish are known as pilot whales.

The tail is key to a whale's propulsion, as well as protection. When a whale breaks the surface of the water to breathe, it is the tail that propels it upward. A whale's tail is horizontal to assist and direct its rise and fall. The tail of a whale lies parallel to the water, while a fish's tail is perpendicular. When whales flex their tales, it is called lobtailing. Breaching is popping out of the water and splashing back in.

Author Acton observed that whales do not hear well, but their vision is excellent—although their eyes are very far apart. And Acton noted whales are rarely found sleeping, except in the calmer northern latitudes. From a scientific perspective, Henry Acton was very knowledgeable for his era.

Acton confided in his son about the familial love of whales. A female gives birth to one baby—ten to fifteen feet long—per year; young whales remain with their mothers about a year. Whalemen seek the baby whale to lure the mother in for a double kill. Henry Acton delivered this brutal assertion after describing the undying love between a mother and infant whale.

Once a whale was spotted, often by a lookout high on the crow's nest or crosstrees of the mast, whaleboats were launched to chase the leviathan. Whaleboats were thirty feet long and weighed five hundred to six hundred pounds. "The first and principal thing, my son, in the whaling ships, are the boats, which are made to float lightly upon the water; their bow and stern are made sharp, and they are capable of being rowed with great speed, and readily turned round."[25] The whaleboat carried six to eight men as well as a mast and a sail.

The crew in the whaleboat was uniform. Historian Henry Beetle Hough explained the role of the boatsteerer, who threw the first harpoon: "[He] pulled the forward oar in a whaleboat, darted the harpoon into the whale; and then [switched places with the mate and] steered the boat while the mate used a long, sharp lance for the kill."[26] Thus the mate got credit for the kill, but it was the boatsteerer who first attacked the whale.

The role of the boatsteerer was key. When the sailor threw the harpoon—aiming for the back of the whale's head—he had to be accurate and strong. Once the harpoon was secure to the whale, it was "fast." And the harpoon, also called an iron or lance, was tied to a line, or warp, fastened

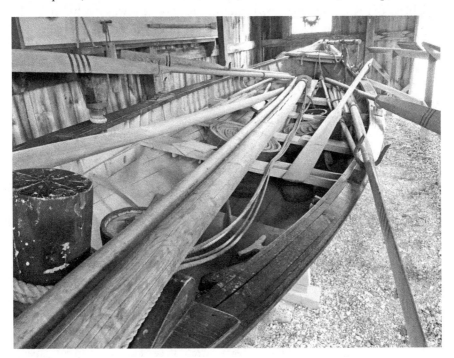

A whaleship had three or four whaleboats, each laden with hundreds of pounds of lines, oars and gear. *Courtesy of Mystic Seaport; photo by Joyce Dresser.*

to the whaleboat. Maneuvering the whaleboat in the lee or blind side of the whale was essential to avoid visual detection.

"The wounded whale, in the surprise and agony of the moment, makes a convulsive effort to escape; then my dear son, is the moment of danger." Henry Acton's story gathers suspense: "The boat is subjected to the most violent blows from its head or its fins, but particularly from its ponderous tail, which sometimes sweeps the air with such tremendous fury, that both boat and men are exposed to one common destruction."[27]

Once their quarry was harpooned, or lanced, whalemen had to ascertain whether the whale would sound—by diving deeply—thrash the whaleboat with its powerful tail or swim swiftly away, towing the whaleboat along. The response by the whaleboat crew was critical.

"Everyone pulled frantically at the oars to escape the whale's lashing tail. The whale submerged and was off at sixty miles per hour with the smoking rope going over the bow in a steady stream."[28]

"Whales do not always sound when ironed, sometimes swimming along on the surface at a terrific pace, towing the boat astern in a smother of spray. Old whalemen called this performance the 'Nantucket sleigh ride.'"[29]

Unless the whale escaped by losing the harpoon, it was captured, killed and towed to the whaleship to be harvested. Once the men and their prize reached the whaleship, the lines were cut away, fins tied together and the body of the whale secured, with the head affixed to the stern of the ship, the tail to the bow. This alignment balanced the great weight of the whale against the ship.

Cutting-in, or flensing, meant turning the whale carcass to peel off the blubber.

On harvesting the whale, "All hands would labor at the winches and windlass to rip long sections of the dense blubber from the dead whale floating along the starboard side so that it could be lowered through the yawning hold in the deck into the cavernous blubber room below."[30]

Cutting-in meant to peel back the blubber in a "blanket piece" off the body of the whale. This was done with very sharp spades slicing through the blubber. Chunks of blubber could weigh as much as half a ton. Each piece would be hoisted onto the deck with a windlass, then sliced into long, maneuverable pieces nearly a foot thick. Known as "horse pieces," these hunks of blubber were passed down into the hold and stored until time to be tried out, which entailed slicing the horse pieces to be boiled down to oil.

The most valuable part of the sperm whale was the head, a great cavern holding spermaceti and blubber. Whalemen removed the spermaceti with

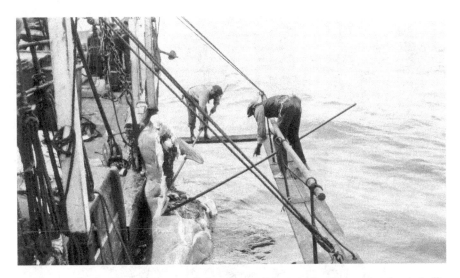

Peeling the blubber off a whale was called cutting-in. It was similar to removing the rind off an orange. Pictured here is the whaler *John Manta*, 1920s. *Courtesy of Martha's Vineyard Museum.*

buckets dipped into the cavity of the whale's head to salvage this valuable commodity. As the cutting-in continued, whalebone and jawbones were removed. Once all the blubber and spermaceti was harvested, the carcass was released to sink beneath the waves.

Initially, blubber was lowered below deck into the large blubber room, between the captain's quarters at the stern of the ship and the crew's quarters in the fo'c's'le, or forward section. The blubber was taken off the deck so another whale could be captured and flensed if possible. For a few days, the blubber could be stored below without becoming too noxious.

The next step was to cut the blubber into long strips, or horse pieces, and passed back up on deck to be tried out on the brick stoves. It was minced or sliced into pieces that could be easily handled. These chunks of blubber, called books or bibles for their shape, were boiled in trypots on the forward deck, or foredeck, of the ship. The small slices had the look of a book, or the pages of a book, and were tossed into the sizzling vats to be boiled down into oil. Because they were thinly sliced, they reduced faster than larger chunks.

The brick tryworks was secured on the ship's deck. With the tryworks beneath the sails, the possibility of fire was very real. A water reservoir beneath the brick tryworks offered minimal protection. Fires aboard

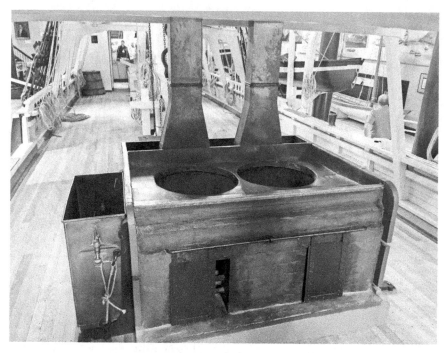

The tryworks was a heavy brick stove located ahead of the foremast. *Courtesy of New Bedford Whaling Museum; photo by Thomas Dresser.*

whaleships were usually contained and quickly extinguished. Each of the two iron trypots on the works held as much as 250 gallons of oil.

Trying out began with a fire beneath the trypots, which had fresh water in them. Once the water started to boil, chunks of blubber were dropped into the pots. As the blubber melted into oil, it was removed into cooling tanks and poured into wooden casks or barrels for storage.

The job of the cooper was to assemble barrels from staves and hoops stored below deck. A typical barrel held thirty-one and a half gallons of whale oil.

Scraps from the minced horse pieces were tossed into the firepit to supplement the wood fuel. The smell of burning blubber was noxious. Smoke from the boiling blubber was dense and dark. The operation could last up to a week, depending on the size of the whale, with the fires burning twenty-four hours a day. Smoke from the tryworks blackened the sails, was greasy and dense and lent a caustic smell to the men who fed the fires to boil down the blubber.

While the tryworks were in operation, the sailors had to be fed. On occasion, the cook would toss chicken into the burning oil to be deep fried or dropped dough in the vat for doughnuts. Once the blubber had been tried or boiled, it was called "crackling."

Whaling was a dirty, dangerous, tedious occupation.

Aboard a whaleship, there was never a dull moment when there was a whale to chase, cut-in or try out. Dull moments arose when there were no signs of whales.

Chilmark's Ellsworth West signed on the whaler *James Arnold* on a voyage around Cape Horn and into the Pacific from 1882 to 1886. The *James Arnold* had four double-ended thirty-foot whaleboats. Each whaleboat carried six men, with a steering oar, five oars and a mast and sail. A quarter mile of Manila line, attached to the harpoon, was neatly coiled in the bow.

After a brief stop in the Azores, the *James Arnold* rounded Cape Horn, sailed into the Pacific and along the coast of Chile. Ellsworth West was promoted from an able-bodied seaman in the fo'c's'le to boatsteerer, in steerage. His share of the income, or lay, increased from 1/200 to 1/100 of the voyage receipts—pay was determined by berth on a whaleship.

"Thar she blows!" A pod of whales was spotted by the lookout high in the crow's nest on the mainmast. The *James Arnold* came up on a starboard tack and lowered three port whaleboats in the lee of the ship, approaching the pod of whales from downwind so as not to startle them. As boatsteerer,

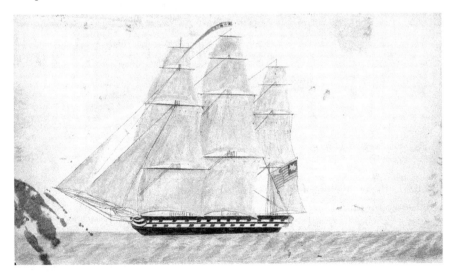

An artistic whaleman captured the detail and serenity of a ship at sea. *Courtesy of the Martha's Vineyard Museum.*

Ellsworth West targeted a whale and threw his harpoon. The startled whale smashed its flukes, soaking the seamen. Then the whale sounded, and the line paid out, smoking, while the crew doused it with water so it would not burn. The whale surfaced; the mate threw his harpoon and killed the whale.

The whale was towed to the whaleship and secured. "The cutting stage was lowered out over the whale and a large hole cut in the blubber behind the head into which a heavy blubber hook suspended from the cutting tackle was slipped." This was how they attached the whale to the ship. "Men in long boots stood on the cutting stage and scored the blubber in a 5-foot swathe with keen, long-handled cutting spades. The blubber peeled off the carcass like so much birchbark."[31]

Fires were lit under the trypots, and the blubber boiled down to oil. Spermaceti was bailed in buckets from the whale's head and stored separately.

For two years, the *James Arnold* cruised off Chile, then headed to the Galapagos Islands, west of Ecuador, farther into the Pacific. Its take was thirty-nine sperm whales and one right whale, which produced 2,800 barrels of sperm oil and 40 barrels of whale oil.

Once the whaleship reached port, the casks of oil were hoisted out of the hold onto the pier. Hundreds of barrels of oil were draped in seaweed to prevent evaporation by the sun. Another whaling trip had been completed, and it was time to determine the proceeds. Before the oil could be sold, however, it had to be measured by the gauger, a harbor official with a long pole who determined whether each barrel of oil was sufficiently full.

There was money to be made from whaling. Ellsworth West, as boatsteerer, struck eight sperm whales. He returned to the Vineyard with $750 in his pocket. Today, West's pay would be valued at $18,000 for four years at sea.

Captain John Morse was the son of Uriah Morse, the first ferryman who rowed back and forth to Chappaquiddick, in the early 1800s. Uriah charged two cents a ride; he also built whaleboats and barrels.

John Morse, Uriah's eldest son, was captain of several successful whaleship ventures. He was master of the *Hector, Eliza Adams, Rhine* of Edgartown, *Russell* and *Sarah* of Edgartown. In 1849, he brought Vineyarders to California, prospecting for gold.

This view of Edgartown Harbor includes Morse's Wharf, with the widow's walk of Captain John Morse's house in the background. *Photo by Joyce Dresser.*

Morse built a wharf into Edgartown Harbor to serve whaleships that drew too much water to enter Nantucket Harbor over the sandbar. Morse's Wharf, known as North Wharf, had a sail loft and a marine railway to access a boatbuilding business. Today, Morse's Wharf, an extension of Morse Street, houses the Edgartown harbormaster and Edgartown Marine.

John Morse built a mansion at 80 North Water Street in 1840, "a grand house with a front porch of two stories, pillared and crowned like a Greek temple."[32] Morse died at forty-eight, off Paita, Peru, in 1852, then captain of the *Sarah*.

4

WHALESHIPS

A whaleship was little more than a floating penal colony for prisoners sentenced to years of hard labor, and in constant danger of sinking.[33]

Harmony, the first whaleship to sail from Holmes Hole, returned from Cape Verde with 250 barrels of sperm oil after an eight-month trip in 1816. The *Apollo* left Edgartown for the Pacific on June 19, 1816, under Captain Jethro Daggett, and was reported to have netted 1,100 barrels of sperm oil. That year, New Bedford had thirteen whaleships at sea, and Nantucket had twenty-eight. Martha's Vineyard had only the *Harmony* and the *Apollo*.

Today, the *Charles W. Morgan* is the last surviving wooden whaleship from a fleet that once numbered 2,700. No other wooden sailing whaling vessels are extant.

Built in New Bedford in early 1841, the *Charles W. Morgan* cost $50,000. A shipyard owned by a family with Chilmark ancestry, the Jethro and Zachariah Hillman Shipyard, built the *Morgan*, which was named for investor Charles Waln Morgan of New Bedford.

Charles Waln Morgan was a businessman who ran a bank and a spermaceti candle factory and sold sperm oil to lighthouse keepers, businesses that paralleled the Vineyard's Daniel Fisher. Morgan was a Quaker, an abolitionist, and at his height owned fourteen whaleships, of which seven had a Vineyard captain.

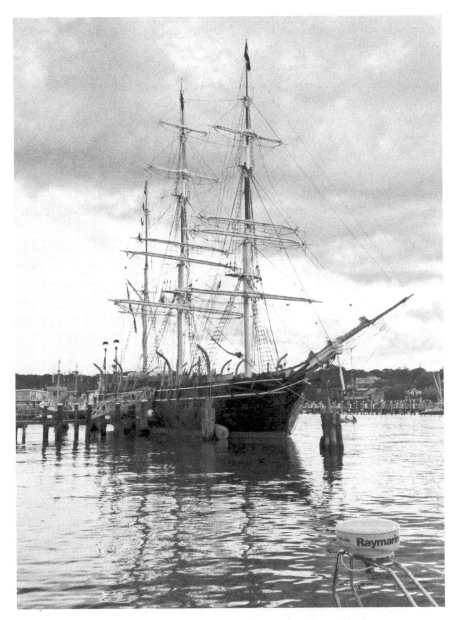

The *Charles W. Morgan* has survived nearly 180 years, most of the time in salt water, a natural preservative. Evening in Vineyard Haven Harbor, 2014. *Photo by Joyce Dresser.*

The *Morgan* was built with two decks below the top deck, three masts and a copper-coated hull. The first deck below and forward was the forecastle (fo'c's'le) where the crew bunked, in the bow of the ship. Midships was the blubber room where horse pieces were stored, awaiting trying out.

At the rear of the ship, the captain and mates dined and bunked. A telltale compass below deck was linked to the binnacle, which housed the compass on the main deck, so the captain could follow the ship's route from below. The lower deck or hold was used for supplies and stored up to ninety thousand gallons (three thousand barrels) of whale oil.

The *Morgan*'s original oak keel is still functional. Yellow pine and white oak were used in construction, with three-inch-thick yellow oak in the ceiling.

White oak was used in a whaling ship because it was available and functional. The keel was often made of sturdy rock maple or oak. The transom or stern of the vessel was live oak, as were the apron and side counter timbers, which strengthened the stem or forward section of the ship. Tar paper and copper sheathing enclosed the ship's keel. Because the *Morgan* has been in salt water virtually since it was built, much of the underbody has been preserved.

The stanchions, or support beams, were locust. Southern pine was used to frame the deck. The knees supporting the deck were juniper. Planking was white oak and Southern pine. Oakum was used to fill spaces between the planks.

The *Morgan* is 110 feet long, 27 feet wide, with a draught of 17 feet and a volume of 351 tons. When it was launched on July 21, 1841, false gun ports were painted along the gunwales to ward off pirates.

Most whaleships were barks, with the two forward masts square-rigged; the mizzenmast, at the stern by the wheel, had triangular sails running fore and aft. Full-rigged meant square-rigged, with square sails. The topgallant crosstrees were the yardarm, or spar, which ran at right angles to the masthead. This was the crow's nest, where the lookout was stationed, searching for whales.

Davits supported whaleboats, lowered by block and tackle when a whale was sighted. The whaleboats were stocked to go at a moment's notice, akin to today's lifeboats. "In the whaleboat, in addition to the four oars and steering oar, were usually two harping irons (harpoons) as well as lances and rope (known as warp). Each boat normally carried a hatchet to cut the line should something go seriously wrong."[34] Sailors would scurry over the gunwales into the whaleboats, be lowered and set off after the whale,

The cook worked in the caboose of the *Morgan* to feed the crew of the whaleship. *Photo by Joyce Dresser.*

rowing diligently at the command of their mate.

When a whale was killed, it was dragged to the whaleship to be butchered for cutting-in. With the stage rigged over the side of the whaleship, rocking in the waves, it was dangerous but necessary to stand on the back of the whale to carve off great chunks of blubber with cutting spades. The blubber was then hoisted onto the deck and stored below. A monkey rope or safety harness was attached to a man with a bucket who hovered over the head of the whale, the case, to bail the spermaceti. These tasks took place simultaneously on a rocking whaleship.

Of various supplies, Melville wrote about the dangers of whaling, accidents involving capturing and harvesting a whale, "and especially to the destruction and loss of the very things upon which the success of the voyage most depends. Hence, the spare boats, spare spars, and spare lines and harpoons, and spare everythings, almost, but a spare Captain and duplicate ship."[35]

Starboard and larboard (port) are the right and left sides of the ship, respectively. Larboard was the original term for the left. A third whaleboat would be the waist boat, midships. If there were more whaleboats, they would usually be identified by the mate in charge.

Henry Beetle Hough recounted a whaling incident using such terminology:

> On Friday, June 23, 1865, the larboard boat struck a whale and was stove "all to pieces" when the quarry came up under her. The same whale, struggling against death, damaged the bow boat also and left a piece of tooth in the wood of her as this boat slipped from his mouth. The fourth mate picked up the men from the larboard boat and hauled in the wreckage.[36]

A crew of thirty men manned the whaleship. In addition to the captain, mates, boatsteerers, harpooners and able-bodied seamen, other crew members performed necessary functions. A rope-maker checked on the

whale line, or warp; the blacksmith sharpened the harpoons; a cooper assembled barrels or casks for oil. Plus, there was a cook and often a cabin boy to handle smaller tasks.

The windlass or giant crank was used to manually hoist the anchor, which weighed more than a ton. The windlass was also used to haul the massive chunks of blubber aboard ship. And the windlass lowered the horse pieces into the blubber room below deck to await trying out.

The first voyage of the *Charles W. Morgan* lasted three and a half years (September 1841 to January 1845) and netted over $50,000. After that, the ship was outfitted for its next venture, the captain and crew signed on and the *Morgan* repeated that routine for eighty years.

The *Charles W. Morgan* went on thirty-seven whaling voyages. A Vineyard captain was in charge of sixteen of them.

All told, seven of the *Morgan*'s twenty-one captains, or one-third, were from Martha's Vineyard:

1) Thomas Adams Norton of Edgartown, born in 1809, was in charge of the *Morgan*'s first trip. Seventeen of the crew were Vineyarders. Second mate James Osborn kept the log. Norton had sailed the *Hector* previously. (Norton was the great-great uncle of the late S. Bailey Norton of Edgartown.)

2) Tristram Pease Ripley (1821–1881) was captain for the *Morgan*'s fourth voyage, which lasted two and a half years. Ripley had sailed the *Champion* previously. His wife was Eliza Mayhew.

3) Thomas Fisher had a house on Summer Street. He was known for strictly adhering to rules aboard ship, although he had a compassionate side. Fisher died in 1885.

4) George Athearn of West Tisbury sailed in 1867 and brought in $55,000. He sailed the *Morgan* into the South Pacific in 1871, seeking sperm whales, and thus avoided the Arctic freeze.

5) George A. Smith (1828–1891), from Maine, married Lucy Vincent of Edgartown and spent five years aboard the *Nautilus*. He was often ill-tempered aboard ship. Smith retired on the Vineyard.

6) James Earle of Edgartown led the *Morgan* on nine trips into the Arctic from 1890 to 1908. He went to sea as cabin boy when his father was mate on the *Europa*. On one venture, Earle captured a whale laden with ambergris worth $150,000. Ambergris was a base used in perfume. Captain Earle, the nephew of Valentine Pease, married Honor Matthews from Auckland, New Zealand, in Honolulu in 1895.

7) At seventy-two, Benjamin Cleveland proposed that the *Morgan* play a part in the 1916 movie *Miss Petticoats*, which paid to outfit the ship for its thirty-fourth whaling cruise. Cleveland sailed the *Morgan* outside conventional shipping lanes on his return to the States in 1917, thus avoiding U-boats during World War I.

The *Morgan*'s thirty-seventh and final whaling voyage was in 1920 and realized a return of $25,000, half of its first venture. Over the ship's eighty-year whaling career, the *Charles W. Morgan* harvested 152,934 pounds of whalebone and 54,483 barrels of whale oil.

After its final voyage, the *Morgan* was moored in New Bedford while the owners determined its future.

On June 30, 1924, the steamship ferry *Sankaty* caught fire in New Bedford Harbor and drifted against the moored *Morgan*. Prompt, skillful work by the Fairhaven Fire Department saved the *Morgan* from the conflagration. And although the *Sankaty* sank, it was resurrected and restored to service.

Later, in 1924, the *Morgan* was brought ashore to a sand berth at Round Hill, South Dartmouth, and established as a seaside museum. Over the next decade, more than one million visitors toured the ship. Retired whaling captain George Fred Tilton of Chilmark enjoyed showing off the vessel while recounting his own exploits.

Just prior to the United States' involvement in World War II, in 1941, the *Morgan* was towed to Mystic Seaport and has remained there ever since. The *Morgan* is the second-oldest merchant ship in the country, next to the USS *Constitution*.

Mystic Seaport undertook an aggressive effort to restore and rebuild the *Charles W. Morgan* in 2008. Salt water had preserved many of the *Morgan's* timbers, which made it easier to repair the ravages of time. Restoration took six years and cost $12 million.

Of nearly three thousand whale ships that went on fifteen thousand voyages, the *Morgan* is the only one to survive. Matthew Stackpole, ship historian for the *Morgan* restoration, described the *Morgan* as "a perfect portal, a perfect vehicle for the whole story"[37] of whaling.

In the spring of 2014, the *Charles W. Morgan* was towed to New London, Connecticut, to be rigged with new sails, then on to Newport, Rhode Island. The ship visited Martha's Vineyard for four days in June 2014, its first Vineyard visit. Hundreds of people toured the ship. Then the *Morgan* sailed on to New Bedford, Providence and Boston before returning to Mystic Seaport.

Of the 2014 sail, Vineyard reporter/historian Tom Dunlop recalled how nimble the *Morgan* was in its tacks and turns. "How, I fretted, do you take in the final passage under sail of a National Historic Landmark, the last wooden whaleship left to the United States, the oldest commercial vessel in the country?"[38]

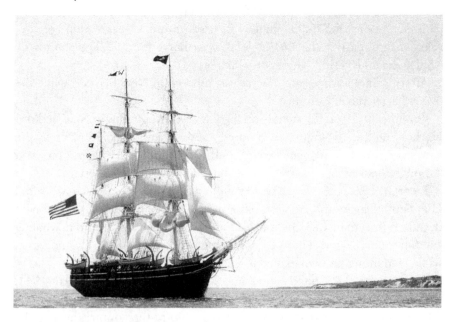

In 2014, the *Charles W. Morgan* was launched for its thirty-eighth voyage and sailed to Martha's Vineyard for the first time. *Courtesy of the* Vineyard Gazette; *photo by Ivy Ashe.*

Keeping a whaleship in good repair was an essential part of whaling. Captain Ellsworth West recalled sailing on the *Mars* under Captain Leroy D. Lewis, of Oak Bluffs, and second mate David Butler from Nomans Land. The goal of their 1888 voyage was to refit the vessel, painting surface structures, repairing the spars and rigging and checking the sails and whaleboats for damage or wear.

Making money off a whaleship was not always easy. Of one of the *Europa*'s cruises, Captain Thomas Mellen lamented that as part owner, he spent $700 more than he made on the venture. Mellen owed interest on borrowed money. He managed to send home whale oil that paid the debt but worried throughout the expedition that his reputation was at stake if he did not return with a boatload of oil.

Mellen's fortunes changed rapidly. "Two days before Christmas, at ten in the morning, the *Europa* sighted sperm whales, and soon four boats were fast. By late afternoon four whales were alongside; by eleven two more were cut in and the watch set. Christmas Eve saw the fire and smoke of the tryworks, and boiling continued through Christmas Day."[39] Six whales made quite a Christmas.

Sailing a whaleship involved following existing charts, taking advantage of the prevailing winds and having a sense of where the whales were.

Determining the speed of the whaleship was an element in sailing. "Heaving the log" was the means to calculate the speed the ship was moving. It involved a long piece of string with knots tied at intervals of forty-seven feet, three inches. A float, made of a small block of wood attached to the string, was tossed overboard. The string played out with each knot as the ship sailed along.

The speed the string passed out was timed against an hourglass.

Intervals between the knots on the string (47 feet, 3 inches) had the same relationship to the 6,080 feet in a nautical mile that 28 seconds has to the 3,600 seconds in an hour. Count how many knots paid out in 28 seconds, and that determined the ship's speed. If seven knots played out in the 28 seconds, the ship was moving at seven nautical miles per hour. Dragging a line beside a moving ship determined its speed.

Heaving the log occurred daily, at noon, so speed could be recorded every twenty-four hours. However, when actively whaling, the ship's speed was irrelevant. "An examination of hundreds of logbooks of American whaling vessels reveals that American whalemen were rather casual about recording navigational data."[40]

The captain or mate maintained the log. Logbooks recorded where the vessel captured whales, current wind and weather, ship's condition and status of the crew. The speed of the whaleship was rarely recorded. Even though the record keeping was the responsibility of the ranking seaman, "Because of his limited command of English grammar a whaleman's entries ran together without punctuation and capitalization and his spelling was often phonetic."[41]

Another form of documentation aboard ship was a journal kept by an individual seaman. Journals did not carry the official sanction of logbooks. Often, journals contained personal commentary and occasional illustrations in watercolor or pen and ink.

The whaleship *Splendid* of Edgartown sailed on October 15, 1844, under Captain Austin Smith, who maintained the log. A typical entry read, "We carried sail all night; next morning we tried to find a whale but we saw nothing of him we raise a ship to windward of us taking a whale alongside." The *Splendid* "spoke" or passed the *Levi Starbuck*.

In the log of September 1845, Captain Smith listed the men employed aboard ship, as well as those who deserted or were discharged. The *Splendid* returned to Edgartown on April 25, 1846, with 1,900 barrels of whale oil, 450 barrels of sperm oil and nineteenth thousand pounds of whalebone. The death of the first mate was a critical event recorded in the log.

The *Splendid* sailed again in four months and returned three years later, in 1849, with three thousand barrels of whale oil, one hundred barrels of sperm oil and fifteen thousand pounds of whalebone. The *Splendid* was withdrawn from service in 1849 to transport prospectors in search of gold to California but returned to whaling two years later.

More than twenty years later, the *Splendid* was still whaling in the Pacific, under Nathan Jernegan, from October 1867 to May 1872. Jernegan's script was neat, the weather notations simple and often repetitive. The log reads, in part:

Sunday November 17, 1869: "Commences with light breeze from the eastward lagging off and on. Ship under double reefs. Middle part moderate and fine weather."

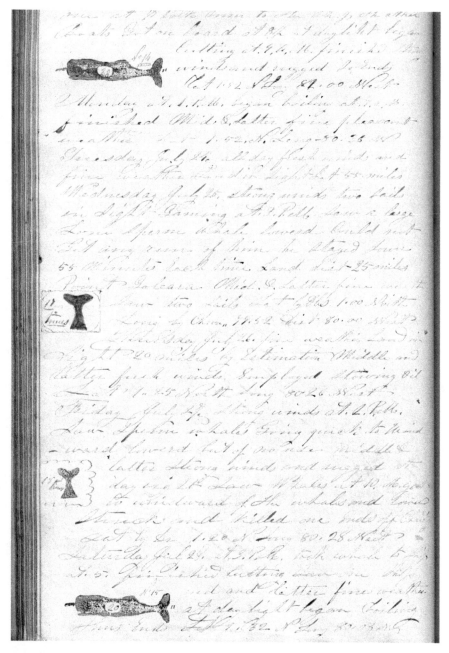

The logbook was the official record of a voyage. This page from the *Virginia*, under Captain Henry Manter, recorded whales caught in the Pacific between 1847 and 1851. *Courtesy of the Martha's Vineyard Museum.*

Sunday February 12, 1871: "raised large lone whales going too the Eastern in far to land at 7 am lowered three larboard boats struck the waist boat at 11:20 am and took the whale to the ship at 2 pm at 3 pm commenced cutting at Dark had his boddy in but built topsails fair sail and jib heading off WSW wind light from the NW with fine rain."

Recording wind velocity and direction plus captured whales filled the majority of logbook pages. The ship's log has become the critical piece of data to assess the success or failure of whaling expeditions. And of nearly fifteen thousand whaling expeditions, fewer than a quarter of the ships' logs are extant. Stuart Sherman, a librarian at the Providence Public Library, published *The Voice of the Whaleman* in 1965, cataloguing existing whaling logbooks at that time. His comprehensive work is an excellent place to begin research on the vast body of information available on whaling ventures.

Captain Edwin Coffin's house, at 88 North Water Street, was built about 1840. Coffin was both a shipmaster and a ship owner.

From 1835 to 1839, Coffin was captain of the *George and Mary* of Edgartown, named for his siblings. He was one of several local masters of Edgartown's *Splendid*. Jason Luce and Nathan Jernegan also captained the *Splendid*. After his whaling career, Coffin served as a lieutenant in the Union navy during the Civil War, then retired to farm in Lambert's Cove.

Coffin's son Edwin Jr. was born in Edgartown in 1850. He went to sea at fifteen and became master in 1889, retiring in 1908. He went whaling out of San Francisco and steamed into the Arctic, captain of the whaleship *Rosario* on eight Arctic voyages, from 1889 to 1898, until the *Rosario* was abandoned.

5

THE CREW

Martha's Vineyard, while it never had a whaling fleet to compare in size with those of its two great rivals, always furnished far far more than its share of men and masters, mates and boatsteerers for the ships of both of them.[42]

Whaleships sought able-bodied seamen, which meant plenty of opportunity for adventurous young Vineyarders. And while the majority of whaleships were from Nantucket or New Bedford, the captains of these ships were often Vineyarders—always eager to sign on an enthusiastic young sailor, especially with a local connection through family or friends. Vineyard Captain John Morse of the *Hector* out of New Bedford had a crew of twenty-seven men. "This was practically an all–Martha's Vineyard crew, and two of the officers, Thomas Norton and George Luce, later became famous whalemen."[43] Vineyarders served as crew on many a whaleship, regardless of the port.

Vineyarders turned to whaling more than any other occupation in the mid-nineteenth century. And they often began their careers as young as thirteen as cabin boys. In the decade from 1810 to 1819, some twenty Islanders signed on with whaleships. The next decade, 1820 to 1829, saw a rise to seventy-two men joining whaleship crews. This was the early peak of Vineyard whalemen. "I think that the love for adventure and the uncertainty that accompanied the hazardous industry of whaling, along with the beauty of our ships, must have had an influence that made for the whalemen many friends."[44] It was a popular career.

The first Vineyard whaleship to sail into the Pacific was the *Apollo*, which left Edgartown in 1816. Once whaling expanded into the Pacific, the need for more men increased. While Martha's Vineyard would never field as great a whaling fleet as Nantucket or New Bedford, the Vineyard contributed many men, dozens of whom became expert whalemen and captains.

Whaling was very labor-intense. Once at sea, when a whale was sighted, three or four whaleboats would be lowered to chase the leviathan. A typical whaleship required sufficient crew to man three whaleboats, eighteen men, plus three or four ship-keepers to oversee the whaleship. The adjunct roles of cooper, blacksmith and cook meant additional crew. Conversely, a typical cargo or merchant ship required about a dozen or so men. Whaling required a lot of men.

It was a challenge to find a good crew. In preparation for a whaling voyage, a vessel would be fitted out with supplies and rations, and at the last minute, a member of the crew might have a change of heart or ill health or just disappear, and the captain would have to find a replacement. This could happen on the voyage as well, far from home. Because whaleships had to travel long distances, often a captain had to recruit crew in a far-off land if sailors died or deserted.

African Americans or Native Americans were signed on often. Historian Arthur Railton stated that racial diversity on whaleships was the norm. Multiple nationalities made up the crew of whaling ships; able-bodied seamen were always in demand.

While whaleships initially employed a crew that was primarily white, Portuguese sailors often signed on when a whaler moored in the Azores or Cape Verdean islands. When the whaleship returned to the Vineyard, the Portuguese whalemen often settled there to make a new life. Several Portuguese communities still thrive on the Vineyard; a centerpiece is the Portuguese-American Club in Oak Bluffs.

Wampanoag sailors of the local Native American tribe were appreciated aboard whaleships, often as harpooners or boatsteerers. Their innate skill with a harpoon was a welcome addition to the crew. Native Americans often earned the rank of harpooner, which entitled them to a certain recognition.

One of the key characters in Herman Melville's *Moby-Dick* was Tashtego, "an unmixed Indian from Gay Head, the most westerly promontory of Martha's Vineyard, where there still exists the last remnant of a village of red men."[45] Tashtego was representative of a racially diverse crew. Melville added that "the Vineyard has long supplied the neighboring island of Nantucket with many of her most daring harpooners."

The Wampanoag were considered both capable and trustworthy.

Tales of the bravery of Gay Head Wampanoag whalemen were passed down through the years. One singular episode in 1897 involved Joseph Belain from Gay Head, who rescued crew from Captain Joseph Whiteside's ship *Belvedere* when it was trapped in Arctic ice. Belain constructed a canvas boat. Fellow crew George Fred Tilton recalled that without Belain's determination, others would have died. Belain saved Captain Whiteside, who had fallen ill, as well as a member of the crew who had given up. Belain ferried Whiteside's wife ashore and saved everyone aboard ship from encroaching ice.

Paul Cuffe and a partner purchased the whaleship *Sunfish* in the 1790s. Whaling was not Cuffe's primary career, but he was well versed in ocean transport. Cuffe's son William was captain of the whaleship *Rising States* in 1837.

"Whaling was the obvious path for boys to follow as they came of age. This was especially the case for Wampanoag men on Martha's Vineyard, who in the first half of the century nearly all went whaling."[46]

Wampanoag George James of Christiantown faced prejudice because he was a Native American. He spent years before the mast as a member of the crew but was never made an officer. James felt discriminated against by whaleship owners.

In 1816, Elemouth Howwoswee (1799–1841) of Gay Head signed on the *Martha* along with Walter Hillman. By 1823, Hillman, who was white, became captain of the *Maria Theresa* and later the doomed *Ann Alexander.* Howwoswee served as boatsteerer on sixteen various voyages yet was never offered the role of captain.

Alonzo Belain and Francis Peters of Gay Head, both seventeen, signed on the *Sunbeam* as ordinary seamen in 1868. On their return, they were promoted to boatsteerers and then mates. Belain died of tuberculosis in 1887, and Peters was lost at sea the next year. Either man could have become a captain, but both died too young.

Amos Smalley (1877–1961) attained fame as the only whaleman to harpoon a white whale, bringing Melville's fictional *Moby-Dick* to life. Smalley was a Gay Head Wampanoag. He first went to sea at age fifteen

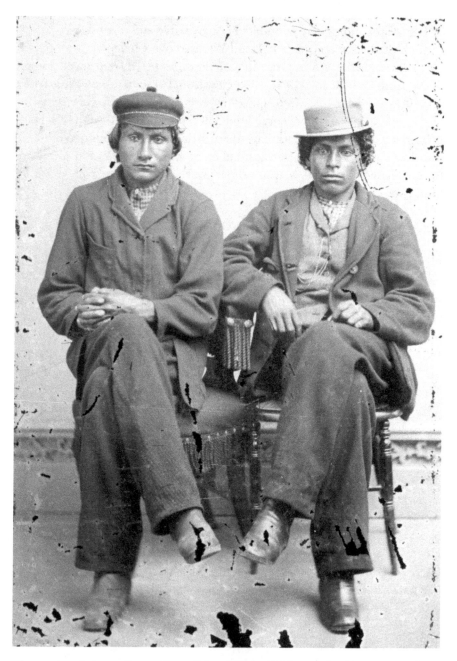

Wampanoag whalemen Francis Peters (*left*) and Alonzo Belain served as harpooners and were promoted to mates. *Courtesy of the Martha's Vineyard Museum.*

and by twenty-five was a boatsteerer-harpooner on the barque *Platina*, out of New Bedford, south of the Azores, in an area known as the Western Ground.

A whale was spotted: "The *Platina's* master, Thomas McKenzie, was incredulous that the all-white creature was a sperm whale but other crew members confirmed the spout."[47] Whaleboats were lowered. Smalley was aboard a thirty-foot whaleboat and managed to harpoon "the 90 foot-long great white whale. This rare, and fear-inspiring being, was believed to be over 100 years old and ran more than 80 barrels of oil."[48] Smalley used a small darting gun with a missile that exploded in the whale, causing instant death.

Catching a white whale was unusual. People doubted Smalley's experience:

In a recent letter to Mr. Smalley, Frank MacKenzie, son of his former captain, quotes from the ship's log, which he possesses, and gives the bearing in which the whale was killed. "It is Latitude 35 North, Longitude 53 East." The entire entry corroborates Mr. Smalley and furnishes further proof that his narrative was true. "They can't call it a yarn any longer," declared the veteran whale-killer.[49]

As whaling included the coastal communities of southeastern Massachusetts, it became more difficult to find white men willing to sign on for long voyages. African Americans found opportunity with whaleships and eagerly signed on.

Aboard ship, the pain of racism was masked by the drudgery of work or tedious doldrums waiting for a whale. However, when an African American or Wampanoag signed on, it was on shore that racial prejudice affected the rate of pay, or lay, offered a seaman. Pay for men of color, whether Indian or black, was usually below that for whites.

Like the Wampanoag, African Americans proved themselves valuable. African Americans found their work respected by crew and officers alike. Like all whalemen, the crew often finished a voyage with little or no income, as they had to pay for supplies purchased from the "slop chest" aboard ship. That said, few crewmembers made much money from their first whaling exploits. The goal was to sign on another venture, gain experience and eventually rise up the ranks to make more money.

In a study of Vineyard crew between 1810 and 1840, a quarter of all whalemen were African American. Whaling provided blacks a chance to feel equal, at least at sea. And those fleeing slavery were considered free

The shipping paper or articles recorded personal characteristics of the crew, including their lay. This shipping paper is from the *Mary Frazier. Courtesy of the Martha's Vineyard Museum.*

men aboard ship. The number of African Americans among the crew of whaleships in the early nineteenth century is evident in whaleship records.

The whaleman's shipping paper, also known as the articles, was a contract between the owner, the captain and the seamen, that spelled out terms of the voyage, date of commencement and pay rate, or lay, for each sailor. Members of the crew were listed according to rank, skin and hair color. Many African Americans were signed on as whalemen. Skin color was listed in various shades, from black to brown, Negro, African, copper and Native American.

Crew lists of Vineyarders who signed the whaleman's shipping paper on New Bedford whaleships are housed at the New Bedford Public Library. An assessment of the lists drew the following calculations by historian Arthur Railton:

- Crew from Edgartown numbered seventy-three, with seven of them black (9 percent)
- Crew from Tisbury numbered eighty-five, with four either black, Negro or copper (5 percent) and one Native American
- Crew from Chilmark numbered forty-four, with eight black (18 percent) and six Native American (14 percent)
- Crew from Gay Head numbered eight, with one black (12 percent) and five Native American (63 percent)

William Martin was the Vineyard's most prominent African American whaleman. He rose through the ranks to become the first African American Vineyard whaling captain.

Skip Finley has researched African American whaling captains. The *Vineyard Gazette* reported, "Over nearly three centuries of whaling, some 175,000 men went to sea in 2,700 ships." The article continues, "The original oil industry—at its peak, the fifth largest business in the United States—whaling offered rich opportunities to all men, regardless of skin color. Based on ships' records, '30 to 40 per cent of everyone who ever went whaling were black,' Mr. Finley said."[50] Nearly a third of the crew is a healthy number of African Americans aboard whaleships.

In the nineteenth century, more than half the island's males between fourteen and nineteen went to sea. Aboard ship, their lives were socially isolated, and "inadequate diets, unsanitary living conditions, and irregular sexual experiences on ship and ashore certainly did something to them physically and mentally."[51] Understandably, these young men found solace and satisfaction when they could socialize with others. They spent free time carving scrimshaw. Singing sea chanteys while hoisting a sail, the anchor or a whale carcass made work a little easier. Some men kept journals. Whaling was male-dominated and offered little in the more genteel aspects of life.

A social event broke the routine of whaling when a visit occurred between two whaleships far from home. This was called a gam. The ships would speak, or meet at sea, and the captains would socialize on one ship—often the crew would visit, too. This brought a semblance of humanity and variety to the drudgery of life at sea.

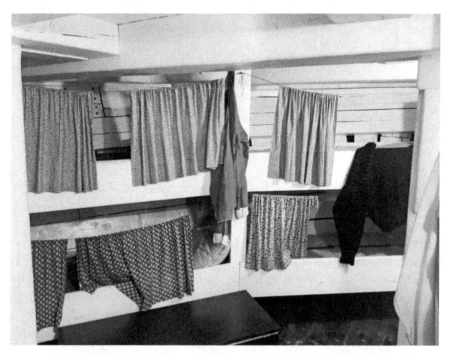

The crew bunked in the fo'c's'le (forecastle) in the ship's bow. *Courtesy of Mystic Seaport; photo by Joyce Dresser.*

Besides a gam, the primary communication was through letters. Letters were passed from one whaleship to another or from a Vineyard whaleship to a makeshift mailbox on a small island in the Pacific. Today, one such mailbox is still in use at Floreana Island in the Galapagos. The barrel at Post Office Bay is a tourist site, but letters are still left and retrieved there.

The Sturgis Library in Barnstable is the oldest facility in the United States to function as a library, dating to 1644. It houses a collection of some thirty letters written by three Vineyard brothers who sailed on whaleships. Their letters are plaintive reminders of the loneliness at sea and desire for contact with home. The letters reveal a struggle to connect over time and distance.

The letters "are poignantly written accounts of life onboard a whaling ship, and express the longing for home, the excitement of the catch." The synopsis by the Sturgis Library notes that the "letters from Charles and Holmes also speak of their longing for home and their wish that other young men not follow in their footsteps."[52] The three Swift brothers grew up in Holmes Hole, now Vineyard Haven. The letters have been transcribed, which eases access.

Asa Swift wrote on December 16, 1868, from the whaleship *Niger*. He missed his family and concluded, "I cannot think of anything more to write. I will close my letter." On Christmas Day he wrote again, noting that he "was glad to get them pitctures and see home looking so well and Sarrah's baby." He made scrimshaw frames for the photos. And "if they should make that shoe factory there tell Homes [his brother] to go into it and not go a whaling if he does he will be sorry for it." As for Willie (another brother), "Tell him never to want to go a whaling."

Shortly after composing this letter, Asa Swift died at sea. He was eighteen years old.

Brother Charles, aboard the *Emma C. Jones*, complained of the lack of mail from home. "I don't like it atole becase I have not had no anser to those letters that I have wrought home." He described the "berls" of oil, and "hopes to fill up the ship and get home in one year from now."

On November 22, 1868, Charles wrote, "I am very sorry to let you know that I am sick of whaling and long to get home onse more to my folks."

Holmes Swift followed his siblings, whaling aboard the *Mary Frazier*, writing on April 14, 1878, "I struck a 20 beririll whail," his first. He was

These pie crimpers exemplify detailed scrimshaw, a passive activity for whalemen. *Courtesy of New Bedford Whaling Museum; photo by Thomas Dresser.*

excited, yet added, "I still do not like whaling and wish I was back safe at home." Poignantly, he noted "that when I left home I was leaving every thing that was dear to me." He cobbled shoes for the crew and carved scrimshaw, repeating, "I shall never attempt to come a whaling."

Holmes Swift, of Holmes Hole, wrote of his second mate, "I love him as a brother all though he is from gay head."

Whaleships from various New England ports found able-bodied crew among the population of Martha's Vineyard. Aboard the Nantucket whaleship *Globe*, which set sail in 1822, Captain Thomas Worth of Edgartown hired his cousin's fifteen-year-old son, Columbus, as well as the Kidder brothers from Tisbury. "Being Vineyard men, they were known to and trusted by their captain. Even better, they were experienced hands."[53] Knowing members of the crew created a level of trust valuable at sea under hazardous or trying conditions.

Assembling the crew was essential preparation for a successful voyage. In the case of the *Globe*, knowing the background of the crew was critical. Thomas Worth had broad Vineyard connections. He hired experienced officers he knew: First Mate William Beetle, Second Mate John Lumbert and boatsteerer Gilbert Smith. Worth also knew two Vineyard seamen, Rowland Jones and John Cleveland. The second boatsteerer, Samuel Comstock, age twenty, was from Nantucket.

These were all young men. Worth, the captain, was only twenty-nine. His mates, Beetle and Lumbert, were twenty-six and twenty-five, respectively. Other members of the crew ranged from fifteen to twenty years old. Youth dominated the crew of the *Globe*, as it did on many a whaleship.

Sailors were paid according to their berth, or rank aboard ship when they signed on. Payment was determined by a percentage or lay of the number of barrels of oil sold at the end of the voyage. Thus, a lay of 1/125 meant that a sailor would receive the value of 1 barrel for each 125 barrels sold. A lay was a fraction of total proceeds. When the seaman signed on, he negotiated his lay depending on prior experience. More experience meant a higher percent of the profits and a shorter lay. An inexperienced man would receive a longer lay. A long lay, like 1/120, meant less pay; a short lay, such as 1/15, meant more money.

In *Moby-Dick*, Ishmael explained when he signed aboard the *Pequod*, "I was already aware that in the whaling business they paid no wages; but all hands, including the captain, received certain shares of the profits called lays, and that these lays were proportioned to the degree of importance pertaining to the respective duties of the ship's company." Ishmael acknowledged, "I was also aware that being a green hand at whaling, my own lay would not be very large."[54]

When the crew had a chance to get ashore, things livened up. Cap'n George Fred told the story of several men having to share the same razor blade as they prepared for liberty. One man, named Darling, was the only member to have a razor. To be fair and keep the razor sharp, Darling said everyone should shave half his face, one after another. When the crew had shaved half their faces, the razor was passed back to Darling, who shaved a second time to finish up. Captain Tilton recalled that after Darling had his second stint, he threw the razor overboard. The rest of the men had to go ashore with half a beard.

Captain Abraham Osborn Jr. attained a level of infamy as captain of the *Ocmulgee* in 1862. The *Ocmulgee* was the first whaler burned by the Confederate raider *Alabama* under Raphael Semmes during the Civil War. Osborn was also involved in the Arctic freeze of 1871, when he lost the ship *George*. A number of years later, as captain of the *Osmanli*, his ship was destroyed and abandoned. Two of Osborn's ventures were successful, however, his terms on the *William Wirt* and the *Almira*.

Abraham Osborn Jr. was first cousin to Samuel Osborn Jr., owner of many Vineyard whaleships. Samuel Osborn's house, at 42 South Water Street, was built in 1834. Abraham Osborn Sr. converted it to an inn. At different times, both father and son served as captain of the Edgartown whaler *Almira*.

6

THE CAPTAINS

It is said that the Vineyard had more whaling masters per capita than any other place, although no data are known to prove it.[55]

While Martha's Vineyard did not send nearly the number of whaleships to sea as its competing ports, the Vineyard certainly was home to many whaling captains. Vineyarders grew up by the water and were well aware of the opportunities to be made aboard a whaleship, so it was natural for a majority of working men to gravitate to the ocean.

"Though personal rivalries between Nantucket and Martha's Vineyard had always existed, the two islands cooperated in the whaling industry to their mutual benefit. Many of the captains who lived in the fine houses on North Water Street in Edgartown had made their fortunes on Nantucket-owned vessels."[56] Rivalry between the islands was superseded by the need to find capable, trustworthy captains. And the success of the whaling venture depended extensively on a capable, competent captain.

The role of a whaleship captain demanded he serve a variety of positions, from navigator of the ship to disciplinarian, doctor or minister as needed. "On board a whaleship the captain had to be the master of his men; the minister to those of his crew in need of guidance; a legal advisor to others; an agent for his owners in port, and a doctor when medical treatment was demanded."[57] On a three- to four-year journey, "the master becomes agent and owner, judge, executioner and everything else you can think of."[58]

The captain mapped the whaleship journey from his cabin. *Courtesy of Mystic Seaport; photo by Joyce Dresser.*

As a rule, the men who sailed on whaleships were not overly religious, although superstitions were not uncommon. Few whaling captains required religious services, but it was an option. Problems arose when whales were sighted and it was the Sabbath—does the captain pursue the leviathan or proceed with a Sunday service? Of Captain James Cleaveland, his great-granddaughter Dionis Coffin Riggs wrote that he always had a Bible aboard ship. Whether or not he conducted services depended on the status of whales at the moment.

Reverend Edward T. Taylor preached in Edgartown and Holmes Hole. He is credited with initiating a tradition of blessing ships prior to setting forth, praying with the captain and his crew for a successful whaling venture.

Whenever a sailor died at sea, it was the captain who read the eulogy and ordered the body, wrapped in sailcloth, cast overboard into the deep.

A key responsibility of the captain or mate on a whaleship was maintaining the log. Logbooks were primarily intended to record the vagaries of the journey; however, some log keepers were artistic, illustrating events like a whale upturning a whaleboat or the thrill of pursuit of the giants of the deep. The man who kept the *Iris*'s log filled its pages with elaborate drawings.

From a business perspective, whale stamps were used to record the types of whale and how much oil was obtained from each capture. Whale stamps were an efficient way to account the success or failure of a whaleship journey.

The men who kept the journals and logbooks on whaling expeditions created folk art, according to a logbook conservator. Not every logbook included illustrations, but it is not unusual to spot a primitive watercolor or pen-and-ink picture in the pages.

Henry Beetle Hough's grandfather was a whaling captain. Hough acknowledged problems aboard ship such as keeping food fresh or water plentiful. Hough was aware of the challenges with crew working and living together in close quarters for a long period of time. And when a medical

situation arose, it was the captain who acted as physician or surgeon, depending on the case. According to nineteenth-century laws, whaleships had to visit a port every five or six months to report any crew with a contagious disease. Arriving in port was an opportunity to obtain skilled medical care as necessary.

Aboard the *Mary D. Hume* in 1892, Hartson Bodfish was injured when a mast fell and crushed his toe. Captain James Tilton was too slow in his response. Bodfish knew he had to amputate his toe and did so himself, gaining, "considerable satisfaction in having performed my first surgical operation."[59]

A member of one crew was blinded by a blast of ammonia and lost his sight aboard a ship commanded by Ellsworth West. Captain West had the presence of mind to send a wireless message asking how to treat his sailor. Within twenty minutes, two ships replied. An American vessel did not know. But a message from an English vessel suggested washing the eye with vinegar. West administered vinegar, and the fellow regained his vision.

The Vineyard had a well-earned reputation for producing many whaling captains in the nineteenth century. Captain Nehemiah C. Fisher was "born on Chappaquiddick, a sort of sub-island of Martha's Vineyard where orange milkweed and beach plums grow."[60] Henry Beetle Hough continued, stating Chappy was known "for its numerous brood of whaling captains and whaling-captains' wives. Three families in as many gray-shingled houses near Caleb's Pond on this geographical fragment produced at one period thirty children, seventeen of whom became shipmasters, and most of the others the wives of shipmasters."

Author Lloyd Hare showered adulation on Vineyard captains, awed that the tiny island of Martha's Vineyard furnished so many whaling captains. Hare noted that over the years, sixty-two whaling captains from Martha's Vineyard brought home more than $1.5 million in sperm oil, whale oil and bone.

Hare praised the men of Martha's Vineyard for creating a niche market based on their energetic efforts and adept seamanship. Whaling captains made significant economic contributions to the well-being of Martha's Vineyard and secured a worldwide reputation of whaling expertise.

Mexico eased trade with the United States in 1821, which opened the West Coast for California-bound whaleships. It was not long before Captain Timothy Daggett of Edgartown's *Almira* left the Vineyard for San Francisco in 1822, followed the next year by Captain Seth Cathcart of the *Massachusetts*. Jared Poole of Chilmark became a San Francisco whaleman. Brothers

BILL OF HEALTH.

𝔘𝔫𝔦𝔱𝔢𝔡 𝔖𝔱𝔞𝔱𝔢𝔰 of 𝔄𝔪𝔢𝔯𝔦𝔠𝔞.

DISTRICT OF EDGARTOWN.

𝔗𝔬 𝔞𝔩𝔩 𝔱𝔬 𝔴𝔥𝔬𝔪 𝔱𝔥𝔢𝔰𝔢 𝔓𝔯𝔢𝔰𝔢𝔫𝔱𝔰 𝔰𝔥𝔞𝔩𝔩 𝔠𝔬𝔪𝔢: I, THE COLLECTOR OF THE PORT OF EDGARTOWN, do, by the tenor of these Presents, Certify and make known, that the Captain, Officers, Seamen, and Passengers of the _Ship_ called the _Splendid Edgartown_ laden with _____ and of which _____ Fisher is Captain, consisting of _This Cy._ Officers and Seamen, and _____ Passengers, now ready to proceed on a voyage to the _Pacific Ocean_ and elsewhere beyond sea, are all in good health.

𝔄𝔫𝔡 I 𝔡𝔬 𝔣𝔲𝔯𝔱𝔥𝔢𝔯 𝔠𝔢𝔯𝔱𝔦𝔣𝔶, That no Cholera, Plague, or other contagious or dangerous disease, at present exists in this Port or its vicinity.

𝔊𝔦𝔳𝔢𝔫 under my Hand and the Seal of the Custom House at Edgartown, the _____ day of _____ in the year of our Lord One Thousand Eight Hundred and Fifty _One_ and in the _76_ Year of the independence of the said States.

_____ COLLECTOR.

A signed bill of health from the *Splendid* of Edgartown, indicating no whalemen aboard had a contagious disease. *Courtesy of the Martha's Vineyard Museum.*

Ephraim and Matthew Poole left Edgartown in the *Vespa* seeking California gold. Captains Henry Cleaveland and John Morse were two Vineyarders who transported prospective prospectors on their whaleships to California.

Whaleship captains performed their jobs to the best of their ability under the circumstances they faced. When a laconic whaling captain observed he had had an uneventful cruise, "this often meant death at sea, mutiny, temporary imprisonment in the ice, loss of a whaleboat, or, sometimes, a fabulous catch of bone and oil."[61] The role of the captain was to maintain order and bring home the whale oil, regardless of myriad distractions, disasters or delays. Many captains are worth mention, but here is a brief list of some notable Vineyard mariners:

ALLEN TILTON (1792–1872) was a whaler in the 1820s. He sailed the ship *Loan* from 1821 to 1823 and returned with 1,700 barrels of sperm oil, "a good and fast voyage." In April 1824, Captain Tilton received 1/17 share of the bounty. William Penn, an ordinary seaman, had a 1/180 lay—such

was the disparity between captain and seaman. Tilton retired from whaling in 1832, bought land in Chilmark and worked as a gentleman farmer for forty years.

ABNER WEST (1811–1902) was born in Holmes Hole, probably in Frog Alley. West went to sea at age ten as mess boy, sailed aboard the *Enterprise* in 1828–29, and was named captain of the *Pocahontas*, which endured a mutiny on its 1836 seven-month cruise.

He married Sarah Elizabeth Hodge in 1847 and fathered five daughters. West sailed in what was known as "the flourishing days of the whaling industry." He commanded two voyages on the *Popmonnitt* and was master of the *Chase* for five years.

During a brief time ashore, West and a partner ran a chandlery shop in Vineyard Haven. There, he sold a flexible bomb-lance harpoon, launched by hand or with gunpowder, equipped with barbs that twisted inside a wounded whale like a fishhook, so it could not be removed. His patent no. 4865 was the first patent by a Vineyarder but not a success.

West returned to the sea as captain of *America*. During the Civil War, he was captain of a ship in the battle between the ironclads *Monitor* and *Merrimac*. West was a master mariner and a distinguished sea captain. His *Gazette* obituary read, "Captain West retired from the sea many years ago and his latter years have been tranquil and contented." West's descendant Chris Baer uncovered his story; Baer's family has a sword and sextant once owned by Captain Abner West.

AMOS HASKINS and JOSEPH G. BELAIN were Native Americans from Martha's Vineyard who became whaling captains. A third Wampanoag, AMOS JEFFERS of Gay Head, was named captain of the *Mary*. Unfortunately, while the *Mary* was being outfitted, Jeffers drowned while fishing off Gay Head.

JOSEPH G. BELAIN served as first mate for decades and eventually was named captain of the *Eliza* in 1890 on an Arctic whaling venture.

Amos Haskins (1816–1861) was the first Wampanoag whaling captain. He grew up in Rochester, Massachusetts, a brother of Samuel Haskins, who saved survivors of the *City of Columbus* in 1884. Haskins married Elizabeth Farmer, and they had five daughters. Haskins began whaling at twenty-five, as second mate. He went on whaling expeditions in the 1840s as a mate aboard the *Annawan*, *Cachalot* and the *Willis*.

In 1850, Amos Haskins assumed the role of captain, replacing the ailing master of the *Elizabeth*. He returned to port with over one thousand barrels of sperm oil, a successful venture. In 1851, Haskins was named to the command

of *Massasoit*, in which he was part owner. The crew of twenty-two included six officers of color. Haskins was also captain of the *Massasoit* on its 1852 voyage. In 1857, Haskins shipped out on the *Oscar*, but he unfortunately died at sea aboard the ship *March* in 1861. His great-grandson Jerome Gonsalves is proud of his ancestor.

ELLSWORTH LUCE WEST (1864–1949) was born in Chilmark among fishermen-farmers who worked the land and the ocean to eke out a living. West claimed salt water in his veins from both parents, so it was natural for him to take to the sea.

Drawn to the California gold rush, in 1849, West's father dug enough gold to buy farmland on Middle Road in Chilmark. Ellsworth's younger brother drove a stagecoach. Decades later, Ellsworth's grandson began a taxi service. Wayne West still drives Stagecoach Taxi today.

Captain's Papers was Ellsworth West's account of his nautical career. Coauthor Emma Mayhew stated in the introduction, "When a whaling captain's voice may really be heard, therefore, telling what he did, where he went, what he observed, there is a rare opportunity to catch history in the act."

West sailed on the *Mars* under Captain Leroy D. Lewis of Oak Bluffs. The second mate was David Butler of Nomans Land. A trip to Truk, an island near Guam, taught West to keep an eye on what was happening. He bartered for goods. As he chatted with the natives, he realized some items they were bartering for looked familiar. The natives had removed trinkets West had already bartered for and tried to sell them to him again. He learned to be more vigilant in his affairs.

West was promoted to captain of a steam whaler and received the opportunity to sail into the Arctic. Throughout his career, Ellsworth West always checked his ship "from stem to stern, from bilge to binnacle."[62] And he knew his location. During World War II, West provided the U.S. government with detailed information about the Aleutian and Caroline Islands in the North Pacific, which proved helpful regarding tides, reefs, currents and the shoreline.

At thirty-six, retired from whaling, he transported miners to Cape Nome, Alaska, following that gold rush, repeating his father's exploits a half-century earlier. When he died in 1949, Captain West was the last whaling master on Martha's Vineyard.

WEST MITCHELL lived in the Hancock-Mitchell House in Chilmark, one of the oldest houses on Martha's Vineyard. His signature is inscribed on a wall. Mitchell "was master of the bark *Massachusetts*, and was sailing off

Alaska with the rest of the New Bedford whaling fleet in pursuit of the bowhead whale. The fleet lingered too long in the Alaskan waters,[63] and Mitchell's ship, along with thirty-two other whaling vessels, was crushed by the Arctic ice in 1871. There was no loss of life, as all the ships' crews managed to escape.

GEORGE FRED TILTON (1861–1932) was born in Chilmark of the extensive Tilton clan. Tilton stowed aboard a whaler at fourteen and spent the next forty years aboard whaleships. Tilton knew whaling: "Like any other business, whaling developed in all its branches and methods, and old ideas were hove over the side to be replaced by new ones, which waaant [sic] always as good as the old."[64] Tilton had a grasp of the practical elements of whaling as well. He recognized that "bone was worth $4.50 per lb. in New Bedford and $1.75 in San Francisco." Economic variables were part of the business.

Tilton is remembered for his effort to rescue whalemen, desperate for food, stranded in the Arctic. George Fred Tilton walked more than 1,500 miles to get help for the crew of the *Belvedere* in the winter of 1897–98. His rescue effort was impressive, but in the meantime, native Inuits had brought caribou to the stranded sailors, so the crew survived anyway.

Vineyarder Skip Finley has researched African American whaling captains. He named several African American or Native American men connected with Martha's Vineyard, who were whaling captains. JASPER MANUEL EARS was captain of Osborn's *E.H. Hatfield*, and JOHN T. GONSALVES whaled well into the twentieth century, including a stint as captain of the *Charles W. Morgan* in 1920.

PAUL CUFFE (1759–1817) was a captain. His mother was a Wampanoag from Gay Head, and his father was African American. Cuffe served aboard a whaleship at sixteen. He and a partner bought a whaleship, the *Sunfish*, in the 1790s, and Cuffe became captain of his own merchant ships. He was active during the Revolution and instrumental in encouraging African Americans to relocate to Sierra Leone. Cuffe was the wealthiest African American–Native American during his lifetime.

WILLIAM MARTIN (1830–1907) was the great-grandson of a slave. Becka was taken from Ghana to the Vineyard in the 1700s. Her daughter was Nancy Michael, known as Old Nance, and her granddaughter, also Rebecca,

This page: Captain William Martin (1830–1907) lived with his wife, Sarah, on Chappaquiddick in a house less pompous than those of his peers. He is buried on Chappaquiddick overlooking Cape Pogue. *Photos by Joyce Dresser.*

was William Martin's mother. Martin was the first African American on Martha's Vineyard to serve as a whaling captain.

In 1857, Martin married Sarah Brown, a Chappaquiddick Wampanoag; they had no children. Martin worked as a cooper and boatsteerer aboard the *Waverly* from 1851 to 1854, earning 1/37 lay. Later, he served aboard the *Almira*. On the *Europa*, Martin was first mate and kept the log.

Martin was promoted to master of the *Golden City* (1878–1880), and followed that as captain of the *Emma Jane* (1883–1884). His final position was master of the *Eunice H. Adams* (1887–90). He left in mid-voyage, after getting injured in a storm.

Captain Martin was master of two of Samuel Osborn Jr.'s ships, the *Emma Jane* and the *Eunice H. Adams*. In a letter to Osborn, Martin described how five men had deserted ship and that "if it had not been such bad weather I should been to sea long ago." He added, "I hope to get a good season. I do not [know] where I will go it depends on the quantity of oil."

Martin served as captain of nine whaling voyages. "In that time his vessels brought back more than 2,658 barrels of the prized sperm whale oil, as well as valuable cargoes of other oil and whalebone."[65] Captain William Martin retired in 1890 and lived out his days on Chappaquiddick, celebrating his fiftieth wedding anniversary in 1907.

THE GOLDEN YEARS

The three decades following 1820 were the golden age of American whalemen.[66]

By the onset of the nineteenth century, New England whalemen had mastered the art of chasing and capturing whales and perfected harvesting blubber, boiling and storing the whale oil and returning to port, generating a successful profit for the ships' owners.

Alexander Starbuck prepared a history of American whaling for the nation's centennial in 1876. His *History of the American Whale Fishery* is the authoritative record of the whaling industry. Starbuck determined that the peak years of whaling were 1835 to 1845—the golden age of whaling, the pinnacle of commercial success. Records of Vineyard whaling expeditions fit neatly within that timeframe of 1841 and 1842 as the apex of whaleship profits on Martha's Vineyard.

The popularity of whale oil as an illuminant and a lubricant catapulted the whaling industry into its golden age. Sperm oil was a powerful incentive. And the years just prior to midcentury proved the glory days of whaling, with many voyages to distant seas. Whaling continued to be profitable. For an investor to fit out a whaleship, sign on a captain and crew and send them out to sea for a year or two or three virtually guaranteed a significant return on investment.

Over the course of half a century, up to the Civil War, the whaling industry expanded, especially through the ports of Nantucket and New Bedford. And whaleships from Martha's Vineyard plied the seas in search of

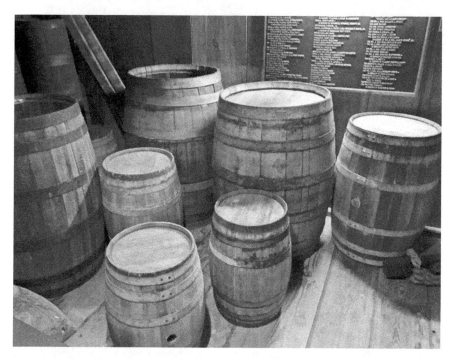

The decade from 1835 to 1845 was the golden age of whaling. *Courtesy of Mystic Seaport; photo by Joyce Dresser.*

whales. Edgartown sent fewer whaleships in comparison to Nantucket and New Bedford but still reaped a substantial reward for its efforts.

An overview of whaleships launched from New Bedford, Nantucket and Edgartown is compelling. These numbers were drawn from Starbuck's comprehensive *History of the American Whale Fishery.* One caveat is that over the years, whaling voyages extended in duration, and these numbers include only ships that sailed out in a given year and do not include their return to port, often years later.

In 1808, Nantucket sent nineteen whaleships from its island port. New Bedford sent fourteen ships. No whaleships left the Vineyard until 1816.

Nantucket lost more than three dozen whaleships during the War of 1812. Another fifty-two ships were wrecked or deemed too decrepit to set out to sea. The port of New Bedford, on the mainland, offered competition to Nantucket. Yet Nantucket managed to recover after the War of 1812.

In 1818, Nantucket sent out forty-three vessels; New Bedford launched twenty-five ships. And only two sailed from Martha's Vineyard, the *Apollo* and the *Loan.*

By the 1820s, New Bedford approached Nantucket for domination of the whaling industry.

In 1828, Nantucket boasted a fleet of sixty whaleships, yet only thirty sailed that year. New Bedford sent forty-nine whaleships to sea. Three ships sailed from Edgartown: the *Gleaner Packet*, the *Loan* and the *Meridian*, the latter under an ailing captain Osborn, who was replaced by the brutal first mate, Fisher.

The years 1841–42 were the peak for the Vineyard; a total of eight whaleships sailed to sea.

By 1848, New Bedford fielded seventy-three ships, Nantucket only nineteen. The sandbar off Nantucket harbor impeded larger whaleships. The Vineyard sent five ships to sea. One whaleship, the *Rodman*, a brig from Chilmark under a Captain Tilton, was withdrawn from whaling and sailed to California in 1849 with prospectors looking for gold.

Just before the onset of the Civil War, in 1860, 246 ships were registered in New Bedford. By 1880, after the war and two Arctic disasters, the New Bedford whaleship armada was reduced to 123.

"Vineyard whalers with the longest and most successful records were *Almira* (15 voyages), *Splendid* (13), *Vineyard* (12), *Champion* (11), and *Mary* (10). All were active during the great whaling years, from 1830 to 1879."[67] A great many other whaleships went on smaller ventures and realized

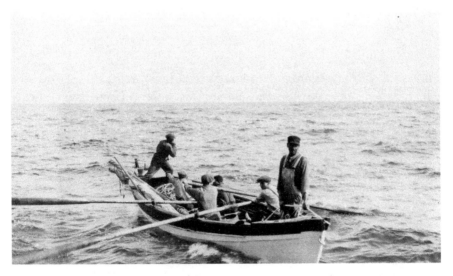

Whaleboats lowered from whaleships chased whales in the Atlantic, Pacific and Arctic Oceans. *Courtesy of Martha's Vineyard Museum.*

significant profits for their owners. The *Champion* and the *Mary* would have been engaged on more expeditions but were crushed in the devastating Arctic freeze of 1871, when three dozen ships were trapped by the ice.

While fewer whaleships sailed from Edgartown, a large number of Vineyarders served as captain and crew aboard ships from other ports. Heading off to sea provided the opportunity for young Vineyard men to make significant money. For nineteenth-century Vineyarders, going to sea proved the most popular of all occupations. The census of 1850 listed 1,463 men. Of those, the Vineyard counted 686 mariners, 342 farmers and 117 laborers. Seafaring was clearly the predominant career choice of the men of Martha's Vineyard.

The era between 1830 and 1850 was indeed the golden age of whaling for the Vineyard as well as the industry as a whole.

By 1858, on the cusp of the Civil War, New Bedford still dominated the whaling industry with sixty-seven launches. Because the intruding sandbar in Nantucket Harbor restricted passage of larger whaleships, fewer ships sailed from Nantucket. That year, Nantucket had only six sailings and the Vineyard five. The *Splendid*, under Captain Shubael Norton and owned by Abraham Osborn Sr., sailed that year but was dismasted in Norfolk, Virginia. The *Splendid* was later refitted and sailed again in 1862 on a five-year voyage.

Successful whaling ventures produced significant profits for the owners. This was an industry where the money was realized immediately after a ship returned to port and the barrels of oil were unloaded on the pier and sold to merchants. The owners garnered the money received for the whale oil; the captain was paid, then the crew. Suppliers received payment, and everyone had an arguably satisfactory settlement of the assets. The owners or financiers claimed the rest.

Payment to crew for time and work aboard ship was determined by the amount of return on the barrels of whale oil. When the ship returned to port and the oil was sold, the lays were doled out to the captain and crew. When the whaleship *Milton* returned to port in 1836, Captain Robert Tuckerman received 1/17 lay, which amounted to $5,882; the boatsteerer got 1/75 lay, or $1,333; the cook earned 1/115 lay, or $869; and the

ordinary seaman got 1/175 lay, or $571. The total income distributed approached $100,000 ($99,994).

Over the years, profits from whaling ventures were not equal, because each voyage brought its own unique characteristics. The trip might be longer because fewer whales were caught; a series of storms or damage to the ship could stall the hunt for whales; disease, desertion or death may have impacted the crew. Cause for delay and myriad misfortunes disrupted any sort of schedule or timetable, but the lure of success and profit inspired whaling adventures to continue as long as whales were still in the ocean and oil was still in demand.

A ship might founder at sea, and the trip would have to be cut short or aborted. Other times, no matter how long or how far the ship sailed or how diligent the lookout in the crosstrees, whales were not to be found. Yet there were many times when a whaleship sailed into a great piece of good luck, coming across a pod of whales and capturing several at once. "The fortunes of whaling were by no means always measured by the length of the voyage, as attested by that of the steam whaler *William Baylies* in 1905, when Captain H.H. Bodfish of Vineyard Haven brought his ship into port at San Francisco after an absence of but six months with a catch valued at $185,000."[68]

A successful whaling venture inspired more and more men to embark on the whaling trade. Whether or not the voyage succeeded proved a matter of skill and luck, weather and leadership, situation and circumstance. And when there was a successful venture, it was documented, albeit briefly, in the logbook. Logbooks obliquely described the daily adventures aboard ship to inform the owners of the activities and actions, both positive and negative, in the whaling venture.

Logbooks were the official record of a whaleship voyage and provide the only verifiable documentation of the specific details of a whaling expedition. Logbook conservators are enchanted when they read records of when and where a whaleship sailed. The conservator feels a personal connection with the firsthand report by the whaleship captain.

Jessica Henze of Northeast Document Conservation Center (NEDCC) said, "As conservators, we don't sit down and read the books, but we are not separate from them. We feel connected by handling these objects that have been to places we have never been." The spirit of whaling and adventure lives on in the whaleship logs.

The *Alexander Barclay* left New Bedford on December 16, 1837:

> ** Monday the 12ᵗʰ, 1838 At 5 am saw a large sperm whale lowered at 7 and struck to the waist boat at 10 o'clock got him alongside commenced cutting*
>
> ** Tuesday the 13ᵗʰ, Cutting in at 5 got in his Body. Head sinking heavy got fast to it with a chain and four part of a Hawser and sat four watches at 3 in the morning it went to daylight. Boiling. So ends these 24 hours.*
>
> ** Monday June 11, 1838 Commenced with fine weather. Killed two whales one to the L boat one to the B boat.*
>
> ** Tuesday the 12ᵗʰ Fine weather, no whales*
>
> ** Wednesday the 13ᵗʰ Fine weather got 2 whales one to the L boat and one to the W boat*
>
> ** Tuesday July 17 Fine weather got a whale to the W boat*
>
> ** Wednesday July 18 Good weather got a whale to the S boat.*

Grammar, spelling and punctuation were not critical to documenting how many whales were captured. The log keeper performed at the level of education he had attained. A ship's log was valuable, however, as it served as a reference point for future whaling ventures.

> ** Saturday December 1 Saw whales going quick lowered and struck them to the W boat Cut him in and commenced boiling middle and last parts fresh breeze day ends*

> ** Monday December 31, 1838 Saw whales lowered and struck to the B boat Cut him in middle strong breezes saw the Gratitude take a whale seven ships in sight. Saw a whale. Lowered. Struck and sunk him to the SB Blowing very heavy thought ourselves lucky to get our boats up without damage. Day ends*

And at the end of the entry, the mate penned these words: "This day's work was enough to make a Master crawl up a steep mountain with a back load of Bibles."

On the first of September 1841, the *Charles W. Morgan* sailed out of New Bedford on its maiden voyage. James Osborn kept the log:

> ** First We weighed anchor about 9 o'clock in the morning in company with the Adeline Gibbs and the New York. Commence with strong breeze from the NE and thick weather.*

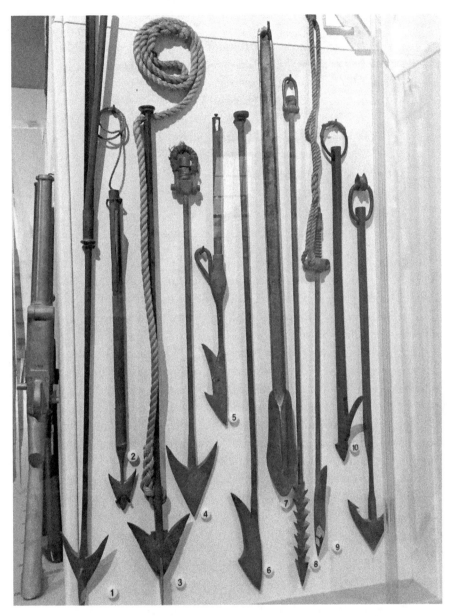

The harpoon, or lance, was the weapon of choice for the harpooner; the mate made the final throw. *Courtesy of New Bedford Whaling Museum; photo by Thomas Dresser.*

** Monday December 13, 1841, About 6 o'clock noted whales of deck lowered the S and L boats. The B and E boats were overhead we put them out and lowered in persuit the Starboard boat struck and killed a cow whale. The school put eyes out to the windward. Middle finished cutting Rainy last part a blowing gale from the NNE course NW by W caught porpoise.*

** Wednesday May 25, 1842, Began with fine breezes from the SE Middle very dull Last part saw a finback heading SW by E Starboard and Larboard boats chased the whales.*

While the most productive year for Edgartown whaleships was 1841, a dozen years later, 1853 was considered the most profitable year for the whaling industry as a whole. More than $11 million was realized in oil and whalebone in that year alone.

As overhunting reduced the number of whales in the Atlantic, whaling captains were compelled to hunt farther and farther from their homeports. Whaleships sailed around Cape Horn at the tip of South America to explore the Pacific Ocean or around the Cape of Good Hope, at the tip of Africa, into the Indian Ocean and thence into the western Pacific. Longer ventures into unfamiliar waters required more time and a greater financial commitment by the whaleship owners. Much longer voyages created additional stresses on individual whalemen and their families due to the protracted time at sea. Longer voyages generally also resulted in higher profits, however, especially for the whaleship owners.

Captain Tristram Pease Ripley (1821–1881) was an Edgartown whaling captain. Ripley was master of several whaleships, including the *Champion*, the *Young Phoenix* and the *Mercury*. He was the fourth captain of the *Charles W. Morgan* and the first to sail it into the North Pacific. His son Benjamin accompanied him on that venture. In addition to whale oil, Ripley sent home 22,700 pounds of baleen, worth more than $75,000.

Ripley's house, built in 1850, was at 7 South Water Street, facing Edgartown Harbor. His wife was Eliza Mayhew; she joined her husband when he sailed the *Mercury* in 1869.

Following his whaling career, Tristram Ripley purchased a wood lot and went into the business of selling coal and wood. The epitaph on his gravestone reads, "Drop the anchor, furl the sail. I am safe within the vale."

THE FINANCIERS

Of Samuel Osborn Jr., "he gradually became pecuniarily interested in the whaling fleet sailing from the port of Edgartown."[69]

W haling required a ship, a crew, a captain and the financial backing to send the whaleship out to sea for months or years at a time. Investors gambled on the success of each whaling expedition and often were rewarded handsomely. Those businessmen capable of financing a whaling expedition deserved recognition and compensation for their efforts. Beyond investors, many merchants ashore operated whale oil refineries or spermaceti candle factories and provided provisions to outfit a whaling expedition. The whaling industry involved myriad people.

Samuel Osborn Jr. was a big player on Martha's Vineyard. He began as a tradesman and built his business. His obituary in 1895 described ownership of various whaling ships, which expanded over the years. Osborn became one of the largest individual owners of whaleships in the United States.

Samuel Osborn Jr. was born in 1823, grandson of Henry Osborn (1751–1808), a hatter, who arrived in Edgartown around 1775. Of Henry's eight children, Abraham Osborn Sr. (1798–1865) was a ship owner, and his son Abraham Jr. was a reputable whaling captain. Samuel Osborn Sr. (1792–1858) was a merchant seaman; his house at 62 North Water Street, next to the old Carnegie library, has been recently renovated.

Samuel Jr. was a whaleship owner like his uncle Abraham Sr. Abraham Jr. and Samuel Jr. were first cousins. Interestingly, Henry Osborn sired eight

children, as did both Abraham Sr. and Samuel Sr. According to Timothy Ward, the great-grandson of Samuel Osborn Jr., "Abraham Osborn Sr. was the dominant whaler in his generation, as Samuel Osborn, Jr. was the dominant whaler in the following generation."

Samuel Osborn Jr. purchased his first whaleship, the *Clarice*, and sent her off under Captain Cornelius Marchant of Edgartown on three successful voyages. Osborn purchased the *Perry* in 1874 and financed two voyages. He expanded his fleet of whaleships rapidly. Some whaleships were the schooners *Emma Jane, Hattie E. Smith* and *E H. Hatfield*; his barks were *Mattapoisett* and *Minnesota* and the brig *Eunice H. Adams*. According to Osborn's obituary, "[H]e was considered the largest individual owner of whaling assets in the United States, with a fleet of eight vessels."

Samuel Osborn Jr. owned the following whaleships at various times: *Almira, Aurora, Clarice, Emma Jane, Eunice H. Adams, E.H. Hatfield, Europa, Hattie E. Smith, Louise Sears, Mary, Mary Frazier, Mattapoisett, Minnesota, Ocmulgee, Perry, Planter, Splendid, Vineyard* and *Washington*.[70]

The bark *Mary Frazier* was typical of Osborn's whaleships, 114 feet long and 25 feet wide. The *Mary Frazier* produced profitable returns, up to a point. It sailed on four voyages under Osborn's aegis.

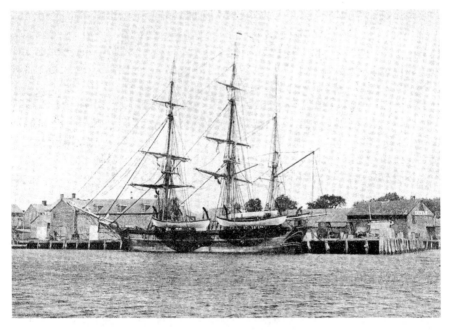

Last of the whalers, the *Splendid*, at Osborn's Wharf, Edgartown. *Courtesy of Charlie Kernick, Martha's Vineyard Antique Photos; used with permission.*

During the first voyage (1876–1880), the *Mary Frazier* whaled off the coast of Africa and captured twenty-seven sperm whales, garnering 13,341 gallons of oil and 2,213 pounds of humpback whalebone. The log for August 21, 1880, recorded approaching home: "Raised No Man's Land next morning, took pilot aboard, came to an anchor in the Port of Edgartown at 9 pm." Total return from the trip was $26,000.

On the second voyage (1880–1883), the *Mary Frazier* realized $38,000. The third trip (1883–1886), under Captain Charles Downes, brought similar returns.

The fourth voyage (1887–1889), however, proved catastrophic. The ship, under Captain Joshua Lapham, was seized by the Portuguese government in the Azores. A diplomatic dispute arose regarding release and compensation for loss of service.

In a letter to the consul general of Portugal, Massachusetts governor Oliver Ames wrote, "I take great pleasure in commending to you Samuel Osborn, Jr. Esq. who is a man or character and ability and enjoys the esteem and confidence of all, in a very wide acquaintance, who know him." Ames complained of the "arbitrary seizure" of the *Mary Frazier*. The governor's letter requested the release of the ship from the Portuguese and appropriate compensation.

Then, the *Mary Frazier* was destroyed by a hurricane and abandoned.

At the time of Osborn's death, in 1895, the case was still unresolved. It was a critical situation at the time, as it epitomized crucial diplomatic elements in a dispute between the United States and Portugal. Osborn lost $36,000 with the destruction of the *Mary Frazier*.

Like many whaleship owners, Osborn was keenly aware of the critical role the captain played in a successful whaling voyage. The wife of a captain could influence his decision whether or not to return to sea. Whaleship owners knew how important it was to have the wives on their side. "They might bribe her to go along with her husband, or they might pull strings to work her husband through her."[71]

During his business career, Samuel Osborn lost a number of whaleships. Still, he managed to have as many as eight ships at sea in 1880. The total gross product for Osborn's ships amounted to nearly $600,000. Osborn also benefitted from the loss of the *Ocmulgee*, captured and sunk in 1862 by the Rebel privateer *Alabama* during the Civil War; Great Britain paid compensation for the attack because of its complicit activity with the Confederate navy.

In the aftermath of the Arctic freeze of 1871, the owners of the five rescuing vessels—*Europa, Midas, Daniel Webster, Progress* and *Lagoda*—sought

congressional compensation for the efforts of their captains and the loss of funds during the whaling season. Attorney Charles Abbott negotiated a deal with Congress to obtain monies; however, he assumed half the proceeds. Samuel Osborn refused to sign on that agreement, as did Thomas Mellen, part owner and captain of the *Europa* during the 1871 Arctic rescue.

In the end, Osborn accompanied Attorney Abbott to Washington to negotiate the deal in 1891, but Osborn acted on his own. Congress approved $125,000 for the ship owners. Abbott received half of each ship's proceeds, except for the *Europa*, which Osborn assumed. Thus, Samuel Osborn kept the entire payout for the *Europa*, which amounted to over $30,000.

According to the financial disclosure statement, a total of $125,000 was paid out in the rescue of 900 people, or $138.89 per person saved. The *Europa* saved 244 people and received $33,890; the *Midas* saved 143 crewmembers for $19,861; the *Daniel Webster* saved 155 people and got $21,527; the *Lagoda* saved 170 people and got $23,611; and the *Progress* saved 188 and got $26,111. Abbott claimed half the proceeds of only four ships.

Of the payment, the *Vineyard Gazette* noted it was "mainly through Mr. Osborn's efforts the government awarded the sum of $125,000 to the owners of the five ships." Osborn earned credit because Congress delivered the payment for their rescue efforts of the stranded crews in the Arctic.

Samuel Osborn proved an energetic and aggressive businessman throughout his career. However, his financial health was never without potential loss through a whaleship or a poor investment. Risk accompanied every decision. On the Vineyard, Osborn lost money when he invested in the Martha's Vineyard Railroad.

Osborn actively supported the Union effort in the Civil War and must have been elated when President Ulysses S. Grant chose to visit the Vineyard in August 1874. Osborn knew how to make a good impression. In 1863, he built a house on South Summer Street for $10,000. Today, it is the Charlotte Inn.

Massachusetts governor John Andrew was a personal friend who often visited Osborn in Edgartown. Osborn was a member of the local school board and served in the state legislature. Samuel Osborn Jr. was dedicated to the local community and did what he could to promote Edgartown.

While Osborn owned one of the largest whaling fleets in the country, his business career was not always been above board. Osborn's career included roles as an "Edgartown storekeeper, whaling mogul, debt dodger, sheriff of County of Dukes County and manipulator of public records."[72] His business acumen was lacking in his younger years. He owed $10,000 in accrued bills when he ran an Edgartown clothing shop and served two months in debtors' prison. Later, as sheriff of Dukes County, he used his position to expunge the lawsuit regarding his debts.

Osborn suffered from Bright's disease and accompanying complications; he died at the age of seventy-two in 1895. Pallbearers at his funeral included whaling captains Hiram J. Cleveland, Richard Holley, Thomas Mellen and Jared Jernegan. As the *Vineyard Gazette* eulogized, "[I]n his passing away Edgartown loses a citizen who contributed much to the upbuilding and maintaining the name and fame of his native town."[73]

Samuel Osborn Jr. made his money in the whaling industry. However, his estate did not garner much after his death: the *Mattapoisett* was auctioned off for $210, the *Eunice H. Adams* for $375 and various lots of whaling equipment generated another $375. A trypot from the *Mattapoisett* was donated to Memorial Park in Edgartown in 1898 by Walter Osborn.

Walter Osborn, Samuel's son, purchased the Timothy Coffin house at 30 South Water Street, which is directly behind the Charlotte Inn, Samuel

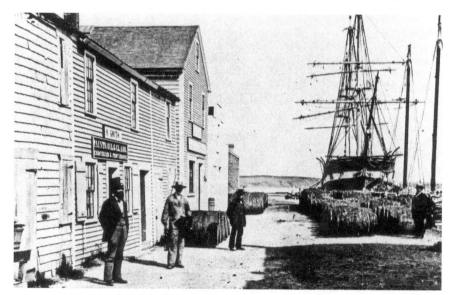

Osborn's Wharf, now the town parking lot by the Edgartown Yacht Club. *Courtesy of the Martha's Vineyard Museum.*

Jr.'s house. It was in this house that Walter Osborn raised eleven children; many of the next generation of cousins summered in this house.

The town wharf was initially owned by Abraham Osborn Sr. and sold to Samuel Osborn Jr. in 1871. This was where whaleships offloaded hundreds of barrels of oil. The wharf was sold to Walter Osborn in 1879, though reduced in size. Today, the wharf is the town parking lot and the Edgartown Yacht Club.

Descendants of Samuel Osborn Jr. are alive and well on Martha's Vineyard. Osborn's son Walter had eleven children, and several cousins live in Edgartown; a few heirs share ownership of a sliver of the pier adjacent to the yacht club. Peter Osborn Bettencourt, a great-grandson of Samuel Jr., appreciates "still owning a part of family history." He recalled peeling potatoes as a child at the Clipper Diner, located where the town parking lot now sits on what was once Osborn's Wharf.

There was money to be made in whaling.

Outfitting a whaleship required sufficient supplies to last years. A partial list of foodstuffs published in the *Vineyard Gazette* in 1853 included the following supplies for the ship *Lydia*, under Captain Peter Pease:

> *5 barrels beef, 6 bbls. [barrels] pork, 4 bbls. flour, 2 bbls. rum, 1200 pounds bread, 60 lbs. butter, 100 lbs. rice, 4 lbs. tea, 4 lbs. chocolate, 15 lbs. coffee, 100 lbs. sugar, 50 lbs. hogsfat, 1 lbs. pepper, 20 lbs. candles, 3 small cheeses, 12 bushels corn, 14 bush. meal, 5 bush. beans, 55 gallons molasses*

A whaleship that cost $7,000 to purchase and $18,000 to outfit required an outlay of $25,000. If the ship returned with whale oil valued at $60,000, after paying off the captain and crew, there was still a substantial profit to be made.

Whaleship expenses included:

Outfits	$18,000
Insurance	$1,750
Depreciation	$1,000
Total	$20,750

That left $39,250. On a two-and-a-half-year voyage, an owner could anticipate a return of 67 percent on the capital per year. An investment of $500 returned the $500 with an additional $840 at the end of the voyage.

A comparable investment of $500 in a bank account for two and a half years at 5 percent interest yielded $62.50. Much more money could be realized by investing in whaling than banking. After two and a half years, a bank account yielded $562.50. After two and a half years of a whaling expedition, the return was $1,340. Whaling was a logical investment.

Profits of a typical whaling expedition, without mishaps, could be significant. Captain Jared Jernegan's share of the *Oriole* voyage, 1863–66, was $16,000, which would be more than $425,000 today.

Dr. Daniel Fisher was neither a whaling captain nor an investor in whaling ships, yet he operated the largest business on Martha's Vineyard, a whale oil refinery, in 1850. He also ran a wharf, a saltworks, a gristmill in West Tisbury, a spermaceti candle factory and a hardtack bakery. And he was a physician. Dr. Fisher was a busy man.

In 1824, Daniel Fisher was enticed to settle in Edgartown to meet the medical needs of mariners on the Vineyard. He developed a reputation as a competent doctor and exhibited the foresight and acumen to anticipate future profits from the whaling industry. His marriage to Grace Coffin, in 1829, linked him to her father, a wealthy whaleship owner. To promote his prominence in 1840, he had one of the most impressive houses in Edgartown built at 99 Main Street.

In 1836, Dr. Fisher bought an existing candle factory along North Water Street. It was a bustling enterprise where whale oil, specifically spermaceti, was refined for the manufacture of candles.

Fisher's whale oil refinery was on the wharf at the site of the current Old Sculpin Gallery by the Chappy Ferry. He stored oil for his refinery in a walled area at what is now the Dukes County House of Correction, colloquially known as Fisher's Fort.

Assuming the role of middleman, Fisher purchased whale oil from whaleships as they returned from their voyages, then garnered the federal contract to supply whale oil to lighthouse keepers along the Atlantic coast. He

donated streetlights to the town of Edgartown provided the town purchase the necessary whale oil from him, which it did. The lamps have since been electrified along Main Street.

Fisher founded the Martha's Vineyard Bank, now Santander. His chandlery sold ship supplies, and he ran a blacksmith shop along Dock Street. Today we know the site as the Old Sculpin Gallery.

Dr. Fisher linked a network of cart roads to West Tisbury, where he harvested wheat and ground it at a gristmill on the Mill River, on North Road, across from Seven Gates. The wheat was then carted back to Edgartown by wagon along a road he had built, Dr. Fisher's Road, which is still extant in most places. The wheat was baked into hardtack and sold to whaling captains to feed their crew.

Fisher proved an enterprising investor and businessman, reputed to be the wealthiest man on Martha's Vineyard in the mid-nineteenth century. He made the most of the opportunities afforded him in the golden era of whaling.

Many Vineyarders were involved in financing and promoting the business of whaling.

Captain Thomas Milton was owner or part owner of several whalers, including the *York* and the *Splendid*. Born in England, he first shipped aboard a whaler as a cabin boy and rose to be sea captain and investor. On a trip to the Orient, in 1833, he returned with a flame tree, or pagoda, which he planted in front of his house. The tree still stands majestically on the sidewalk by his 9 South Water Street home.

James Coffin was a successful whaleship owner. Coffin's daughter Desire married John Osborn (1783–1831), a younger brother of Samuel Sr. and Abraham Sr. The Desire Coffin Osborn house, at 37 Main Street, is now a business called Past and Presents.

The whaling industry annually generated about $600,000, more than $13 million today. It encompassed a variety of supporting businesses, employing dozens of local people. Martha's Vineyard, particularly Edgartown, grew accustomed to the bounty associated with whaling and depended on it for the community's economic well-being.

Captain Cornelius Beetle Marchant (1815–1896) grew up on Wimpenny Lane, near Pease Point Way, in Edgartown. Cornelius was the younger brother of Edgar Marchant (1815–1908), who founded the *Vineyard Gazette* in 1846.

Mail was greatly appreciated in the whaleship era. Mrs. Cornelius Marchant received a letter from her husband's whaling agent Robert Graves, who assured her that his crew was reasonably content, and her husband had received two letters from her. Graves added, auspiciously, that receiving letters from home was greatly appreciated. The agent warned there were many ways men could be enticed to less-reputable activities, and letters were most welcome.

Marchant was captain of four Edgartown whalers, the *Ellen*, *Clarice*, *Emma Jane* and *Eunice H. Adams*; all but *Ellen* were owned by Samuel Osborn Jr. Marchant had to condemn the *Ellen* in 1863, and he later died aboard the *Eunice H. Adams*.

WHALING WIVES

Captain Henry Cleaveland "was a quiet man, taking the storms of his wife's disposition as he took the storms of the ocean, with calmness and fortitude."[74]

Prior to 1820, it was unusual for a whaling captain to bring his wife along on a whaling expedition. When the wife did accompany her husband, their ship was nicknamed a "Hen Frigate." This practice was accepted by the mid-nineteenth century.

With many young Vineyard men away at sea, fewer suitors were available to court unmarried local women. Whalemen courted quickly, and marriages occurred during their brief Vineyard visits. The typical role of nineteenth-century women was to stay home and care for the children. Women were charged with maintaining the homestead, caring for and educating the children and paying household bills.

While Henry Beetle was away at sea whaling, his wife, Eliza, often served as his agent on the homefront. He once wrote her that he had been charged interest on money he owed. Three years later, in 1854, he wrote again that he had trouble obtaining his employment agreement. It was Eliza, his wife, who handled his correspondence and resolved these bureaucratic issues.

Whaling demanded a lot from the family of nineteenth-century Vineyarders. Over time, whaling expeditions lasted longer and longer. Years. In that time, a spouse or a lover or a relative would have minimal contact with their loved one. Communication was via letters carried by other whaleships

on the chance that they might meet on the open ocean. Time passed slowly for those aboard ship as well as those at home. And the dangers of whaling bore the implicit likelihood that the eventual reunion with a loved one might never occur.

One of the first wives to sail with her husband aboard a whaler was Mary Hayden Russell of Nantucket, in 1822. Thereafter, many wives chose to accompany their captain/husbands aboard ship. A common fear among the crew, however, was that the wife was not up to the ardors of sailing.

An excerpt from the letter by an Edgartown whaling captain's wife accompanying her husband on a second whaling voyage poignantly expressed the loneliness aboard ship and separation from friends. In 1860, Susan Colt Norton of Edgartown wrote to her childhood friend, her "dear little Sallie." The letter rhapsodized about their childhood friendship, conversations and gossip, ending with, "Dearest friend, we may never meet again on earth, even while I write, you may be passing from this to the eternal world—let us each strive to live a Godly life in Christ, then we shall have at the blessed assurance of a happy reunion above."[75] The sadness that these two friends might never get together again was a reality in the whaling world.

It was not an easy life aboard a whaleship, far from friends and family. One whaling wife, Clarissa Worth, had not fully comprehended the trials of an arduous whaling journey. It did not suit her. Even with her husband aboard ship, she faded away and died from loneliness far from home.

Not everyone dealt with separation and loneliness the same way. A young woman of seventeen from Holmes Hole married another Captain Worth. Together they sailed aboard the *Gazelle*, but Jane Worth was sick for the whole voyage. She was demanding of her husband and rude to the crew. Jane Worth was the anomaly, however; most whaling captains' wives offered a nurturing atmosphere and a supportive role aboard ship to both their husbands and the crew.

In 1831, Captain William Mayhew (1797–1854) sailed the *Warren* to New Zealand on a whaling venture. When he returned to the Vineyard in 1834, he married his distant cousin Caroline. She joined him on his next expedition. The couple appreciated New Zealand and decided to relocate in 1837. Starting off life anew in a foreign country, with boundless opportunities, was a challenge that suited them—for a while. Finding an attractive new port and settling down was a luxury not afforded many people in this era.

Just as the Mayhew ancestors had lived peacefully with Native Americans on the Vineyard, Captain and Mrs. Mayhew found a peaceful coexistence with the New Zealand natives. Unfortunately, however, their efforts to adapt failed, and William and Caroline Mayhew returned to whaling, aboard the *Powhatan*, in 1846.

Heading back to the Vineyard, eight members of the crew came down with smallpox, and Captain Mayhew himself fell ill. Caroline Mayhew managed to navigate the ship even with many sick crew, as the local doctor in the Cape Verde Islands could not board the ship due to the smallpox quarantine. Caroline believed in cleanliness and fresh air, separated the sick from the well, and healed everyone.

The *Powhatan* reached Edgartown in 1849 with fewer than four hundred barrels of oil after three years at sea. That voyage ended the Mayhews' whaling adventures; however, William sailed on the converted Edgartown whaler *Splendid* to try prospecting for gold. Caroline Mayhew treasured their New Zealand artifacts, displaying them as a museum in her home.

Mary Carlin from Sydney, Australia, sailed aboard the *Emma Prescott* en route to visit her sister in San Francisco. She reached the Sandwich Islands (now Hawaiian Islands) in 1851. Mary Carlin "was a small, dark girl with a lovely singing voice, just sixteen years old."[76] In Honolulu, she met Captain James Cleaveland of West Tisbury, son of Captain Henry Cleaveland of the *Niantic*. James was captain of the *Mary Wilder.*

James Cleaveland and Mary Carlin fell in love. Cleaveland was enchanted by Mary, with her vivacity and her vibrant Irish heritage.

As Mary Carlin's granddaughter Dionis Coffin Riggs wrote, "The power to choose her course seemed out of her hands. She was drifting, drawn by a current of emotion towards this man and his way of life, which might open

Left: Mary Carlin, an Australian girl of Irish descent, fell in love with Captain James Cleaveland of West Tisbury. *From* From Off Island, *used with permission.*

Below: Three daughters of Mary Carlin, two born while on a whaling expedition (*left to right*): Henrietta Deblois, Alvida Ringold and Mary Wilder Cleaveland. *From* From Off Island, *used with permission.*

up a new vista or might mean relinquishing all she held most dear. It was not for her to decide. Fate had chosen for her."[77] The lovers were married at the Seaman's Bethel in Honolulu on November 24, 1851, then spent six months sailing back to New Bedford aboard the *Mary Wilder*.

Mary Ann Cleaveland, the captain's mother, was outraged when she learned her son had married a girl from off-island. When the newlyweds arrived in West Tisbury, Captain Cleaveland tried to ingratiate his new bride with his mother. Too soon, however, even harboring heartache, he set sail on a two-year venture, leaving his wife in the same house as his mother.

Mary Ann Cleaveland ruled her home. It was not a comfortable situation for Mary Carlin. Incidents of disharmony characterized their relationship. The outcome was that Mary Carlin moved out until her husband returned. Then she accompanied him on his next whaling adventure, aboard the *Seconet*, in 1855, and gave birth to two daughters on their five-year voyage. Back on the Vineyard, now in their own home, Mary Carlin Cleaveland gave birth to a third daughter, named Mary Wilder for the ship they first sailed.

By midcentury, a captain's wife aboard ship was no longer unusual. Helen Clark was born in Maine and married Jared Jernegan of Edgartown in 1861. While Captain Jernegan was whaling in the Pacific, he longed for his wife. In 1864, Helen Jernegan packed up her daughter Laura for the trip west.

Mother and daughter boarded the railroad to New York, took a steamer to Panama, crossed the isthmus by train and boarded another steamer up the coast to California. The family was reunited in Honolulu and sailed back together to the Vineyard aboard the whaleship *Roman*. It cost a thousand dollars for Helen and Laura to reach Hawaii, but Captain Jernegan felt it was worth the money.

Laura Jernegan sailed again, in 1868, with younger brothers Marcus and Prescott. With children running freely about, Captain Jernegan chalked boundaries to keep his progeny apart from the whalemen. He hung hammocks for the children on deck.

Helen Jernegan encouraged Laura to keep a diary; one entry included a description of cutting-in a whale, knee-deep in blubber. Laura Jernegan kept her diary from December 1, 1868, through March 1, 1871. Some entries include:

*The men are boiling the blubber that makes the oil.

*We past by Cape Horn to day. It is a large black rock. Some of the rocks look like a steeple of a church.

*They have taken forty teeth out of the largest sperm whale. The deck is very clean and white.

*I have been reading a book. I have been out on deck. I have a little dog.

*It is quite rough today. I am going up on deck.

Laura Jernegan grew up to marry an officer in the revenue-cutter service, but she did not venture back to sea. (For more on Laura Jernegan, visit www.girlonawhaleship.org at the Martha's Vineyard Museum website.)

Leander Owen set sail with his wife, Jane, and son William aboard the

Laura Jernegan, age nine, recorded her observations while aboard the whaleship *Roman. Courtesy of the Martha's Vineyard Museum.*

Contest in 1870. William Owen grew up to be the man who promoted the Victrola gramophone. His dog Nipper was the icon on the RCA record label, listening to "his master's voice." (William Owen's son Knight Owen was killed in a lover's quarrel off Lake Tashmoo, in Vineyard Haven, in 1935.)

The *Contest* was destroyed in the Arctic disaster of 1871, when dozens of whaleships were trapped by ice. Thirty-three whaleships were destroyed, including two from Martha's Vineyard, the *Mary* and the *Champion*. Seven whaleships managed to escape and save the hundreds of crew from the ice-locked whaleships.

No lives were lost in the calamity, but the New Bedford whaling fleet was decimated. Shortly after the ships were abandoned, the wind changed, and many vessels could have escaped the icy grip. Nevertheless, the captains made their decision based on the current weather situation.

While the general public approved of the action of the whaling captains, several owners accused the captains of abandoning ship to save wives and children. Financiers believed the captains were more concerned with the safety of their wives than the ships laden with whale oil. Hence, for a few years, captains on Arctic expeditions were forbidden to invite their wives to accompany them for fear of a similar disaster.

Ellsworth West of Chilmark went to sea in 1882. West could be crusty and was unafraid to offer criticism of captains he sailed under. West returned home when his mother passed away and met and married Gertrude Eager, who taught at the Menemsha School in Chilmark. As an astute teacher and student of navigation, Gertrude West learned to pilot the ship and could identify semaphore flags of other ships at sea.

West was master of the *California* in 1893, with Gertrude aboard ship. She may have influenced his goal to improve the food, cutting salt pork, adding canned vegetables and coffee. However, West was relieved of command of the *California* in 1895 for having his wife aboard an Arctic-bound ship.

Two years later, West assumed command of the *Horatio*, and Gertrude accompanied him again. He outfitted the *Horatio* with the luxury of a piano for her and a gramophone for himself. West took the *Horatio* on three voyages, but the ship ran aground and was declared a total loss. Captain West retired from whaling in 1899 to carve and sell scrimshaw.

Lucy Vincent Smith and George Smith sailed aboard the *Nautilus* from 1869 to 1874. Lucy was intrigued by whaling and recalled watching her husband harpoon a whale. The whale towed the whaleboat rapidly through the water, to Lucy's amazement. She had witnessed a Nantucket sleigh ride.

After meeting friends and sharing letters and news from home at a gam or social visit at sea, Lucy Smith appreciated the close camaraderie she found in the whaling community.

Captain Smith and Lucy sailed the whaleship *Abraham Barker* in 1882. Among the crew was George Fred Tilton, "a redoubtable character of Martha's Vineyard, had got himself in some sort of fracas with the captain."[78] An argument ensued when George Fred refused to be assigned to a certain mate's whaleboat. Tilton recalled the mate "flew right into a fit and told me that I'd go where I was sent and that if I showed any back water he would bust my head open."[79] Tilton punched the mate, giving him a black eye.

The mate told Captain Smith, who ordered the mate to fetch the irons and lock Tilton up. Lucy Smith stood up to her husband, defending George Tilton, to which Captain Smith replied: "Go below, Lucy. Mutiny on my ship!" Lucy Smith stood her ground, and George Fred was not placed in irons. Tilton believed she stood up for him because all three were Vineyarders.

Charles and Parnell (Pease) Fisher were married in 1885; she was in her twenties, and he in his fifties. They embarked on a long whaling expedition aboard the *Alaska* that lasted from 1885 to 1889. Arriving back in Edgartown, Captain Fisher built a new house, imposing and modern, filled with Victorian detail. But Parnell Fisher "preferred her own old home, a block farther up Winter Street, because from there she could not see the sea. She had seen enough of salt water and did not wish to look upon it any more, nor did she ever wish to take ship again."[80] Many captains and their wives had had enough of whaling and preferred to spend their time in more placid endeavors on solid ground.

The *Niantic* was built in 1835 for the Chinese opium trade. A painting of the ship was done about 1836. With the impending opium war, the *Niantic* was converted to a whaler and sailed under Captain Henry Cleaveland, whose three sons, James, Daniel and Sylvanus, joined him.

In 1849, prospectors in Panama sought to reach California, seeking gold. Captain Cleaveland converted the *Niantic* to accommodate 240 eager passengers. He sailed southwest from Panama; San Francisco is northwest. The prospectors confronted the captain. Cleaveland stated that as a sailor one had to sail southwest to catch the trade winds, blowing north and east. The passengers calmed down.

Three whaling brothers of West Tisbury: (*left to right*) James, Sylvanus and Daniel Cleaveland. *From* From Off Island, *used with permission.*

The whaleship *Niantic* was converted to the Niantic Hotel in San Francisco. *Courtesy of Cynthia Riggs.*

When the *Niantic* reached San Francisco, the passengers departed for the gold fields, and the *Niantic* was beached in the harbor. Still viable, and with housing in short supply, the ship was converted to a hotel.

More than a century later, during construction of the Trans America Pyramid, in 1978, the hull of the *Niantic* was unearthed in downtown San Francisco. Cynthia Riggs, the great-great-granddaughter of Captain Henry Cleaveland, was given a four-foot piece of the hull and a bottle of champagne from the resurrected wreck.

Dionis Coffin Riggs, Cynthia's mother, donated the logbook of the *Niantic* to the San Francisco Maritime Museum. Thirty years later, Cynthia and her sisters donated the original painting of the *Niantic* to the museum. In both cases, Davy Hull, a representative of the museum, journeyed to West Tisbury to transport the artifact. Cynthia Riggs enjoys sharing insights and artifacts of her ancestors.

Two Cleaveland sons later served as whaling captains, James on the *Mary Wilder* and *Seconet*, and Sylvanus aboard the *Sea Flower* and the *Mary Wilder*. The family home in West Tisbury is the Cleaveland House (circa 1750), now home to James Cleaveland's great-granddaughter Cynthia Riggs and operated as a bed-and-breakfast for poets and writers.

10

WHALING IN WAR

It is to me a painful sight to see a fine vessel wantonly destroyed, but I hope to witness an immense number of painful sights of the same kind.[81]

Whaling was in its prime between 1820 and 1850. It proved a very profitable enterprise. Whale oil was in demand, so whaling captains confidently expanded into the Pacific Ocean. Financiers relished the wealth delivered to their coffers. Whaling was a career with economic opportunity for those who chose it. However, over the next quarter century, indeed, within a mere fifteen years between 1860 and 1875, the whaling industry experienced a precipitous decline caused by events both internal and external that almost brought the industry to its knees.

The population of whales was seriously depleted in the Atlantic Ocean in the early 1800s. That forced whaleship captains to expand into the Pacific, which required extended voyages, longer time away from home and a greater investment to outfit the ships. And the success of whaling in the Pacific led, dangerously, to whaling in the Arctic, which meant having to contend with the rigors of ice. Thus, the very success of whaling contributed to its decline. Longer trips, farther from homeports, and more frigid conditions added to the expenses both financial and emotional. When whale oil became scarce, the whaling industry had nowhere else to go.

Two discoveries unearthed in the mid-nineteenth century impacted whaling.

The incidental discovery of gold at Sutter's Mill, northeast of Sacramento, in 1849 attracted whalemen to strike it rich without suffering the deprivations of life at sea. Sailors, as well as the get-rich-quick men-on-the-street, sought a life of ease once they successfully seized their pot of gold. Several whaleships were taken out of service in 1849 to transport prospectors to California; the *Niantic*, *Rodman* and the *Hector* come to mind.

The market for whale oil was challenged by the discovery of oil in the ground. Edward Drake, of Titusville, Pennsylvania, dug the first oil well in 1859. Pumping oil from the ground inspired others to promote petroleum as an illuminant and lubricant without the dangers implicit in whaling expeditions. John D. Rockefeller started Standard Oil, and whale oil was doomed.

Oil in the ground was known as "rock oil." Refining oil into petroleum required an investment of time and money. Once the process was refined, oil from the ground delivered a clear signal to the whaling industry that a competitive fuel was available.

The Civil War delivered a devastating blow to the whaling industry. While New England whaleships suffered significantly at the hands of the British during the Revolution and the War of 1812, it was the Civil War that seriously depleted the whaling fleet, nearly cutting it in half.

At the onset of the Civil War, in April 1861, Union forces believed the harbors of Charleston, South Carolina, and Savannah, Georgia, were prime ports for the Confederacy. Ships could transport cotton to England and return with much-needed manufacturing supplies. The Union navy determined to curtail Confederate nautical activity by blockading these Southern harbors.

The Union navy determined that the most efficient way to hinder these harbors was to sink merchant ships and whaleships in the waterways to restrict Confederate ships from accessing their harbors.

New Bedford, the City of Light, was dominated by wealthy Quaker merchants and served as a sanctuary for runaway slaves. City merchants were eager to free the slaves and defeat the Confederacy. In the autumn of 1861, the Union navy purchased sixteen New Bedford whalers and merchant ships, deemed old or unseaworthy, to block Southern ports.

Nicknamed the Stone Fleet, the ships were loaded with granite and sailed down the coast. Each whaleship had holes drilled and plugged below the waterline. The plan was to scuttle the ships off Savannah in December 1861.

The masters of the vessels, assuming they were participating in a patriotic gesture, posed for a photograph on the eve of their historic departure. Rodney French, a whaler and former slave ship owner, named himself "Commodore of the Stone Fleet."

As the ships first approached Savannah, the captains realized Confederate forces had already blocked the harbor with their own ships to keep out Union vessels. The Stone Fleet was not needed in Savannah.

The whaling masters and Union officers then sailed north along the South Carolina coast to Charleston, where the war had begun six months earlier. As is Nantucket, sandbars are a natural deterrent in the Charleston Harbor. Knowledgeable Confederate captains, however, capably maneuvered their ships around the sandbars.

On the evening of December 16, 1861, sixteen whaleships were sunk in Charleston Harbor. Crew and captains then boarded two Federal ships, the *Empire State* and the *Ocean Queen*, and steamed triumphantly back to New York City. Another fourteen to twenty whaleships were sunk on January 26, 1862, for a total of at least thirty. (Records of the exact number of sunken ships are incomplete.) This patriotic effort sacrificed nearly three dozen ships, yet the blockade was deemed a failure, as the captains of Confederate ships simply steered around the sunken vessels. Within a year most of the Stone Fleet had broken apart or disintegrated. No Vineyard whaleships were part of the Stone Fleet.

Following the Civil War, retired whaleman Herman Melville reflected on the failure of the Stone Fleet:

> *I have a feeling for those old ships,*
> *Each worn and ancient one,*
> *With great bluff bows and broad in the beam:*
> *Ay, it was unkindly done.*
> *But so they serve the Obsolete—*
> *Even so, Stone Fleet!*

With the demise of these whaleships, "[I]t seemed, already in the first weeks of 1862, that the whaling industry would soon follow the stone fleet into obsolescence. Deep petroleum reserves had been discovered in Pennsylvania in 1859, ensuring a local and plentiful alternative to

whale oil."[82] When the second Stone Fleet sailed south, it was noted by the *Whalemen's Shipping List* that "1861 had been a year 'of unparalleled pecuniary hardship' owing to the replacement of whale oil with petroleum and kerosene. The Petroleum Age had begun. Even as the Civil War raged, speculators raced west to throw their harpoons into the earth."

In response to scuttling the whaleships in Charleston Harbor, the Confederate navy, such as it was, launched an attack on the North, specifically against the whaling industry. In conjunction with a nominally neutral Great Britain, the Confederate navy waged a war at sea, attacking unarmed whaleships, devastating the industry by sinking the cargo, burning the ships and leaving the crew unharmed but without a ship and penniless in foreign lands. It was a series of brutal attacks that lasted for the duration of the war and beyond.

Two Confederate raiders conducted the majority of damage to the New England whaleships. The *Alabama* roamed the Atlantic from 1862 until well into 1863; the *Shenandoah* threatened ships in the Pacific from 1864 to the autumn of 1865. Both ships were built and commissioned in Liverpool and flew the flag of a friendly nation until they made their attack. Both raiders were armed and used steam and sail power. Together, the *Alabama* and the *Shenandoah* sank nearly one hundred ships, whale and merchant, during and after—yes, after—the war.

And in a modern twist of fate, namesakes of the *Alabama* and the *Shenandoah* are moored in Vineyard Haven Harbor today and sail under the Black Dog moniker.

Whaleships were vulnerable. Whalemen bore no weapons other than harpoons, cutting spades and the occasional pistol. Whalemen were experienced in attacking whales, not defending against an aggressive warship.

In the 1850s, Raphael Semmes, chief lighthouse keeper of the United States, who was born in Maryland in 1810, was charged with ensuring safe

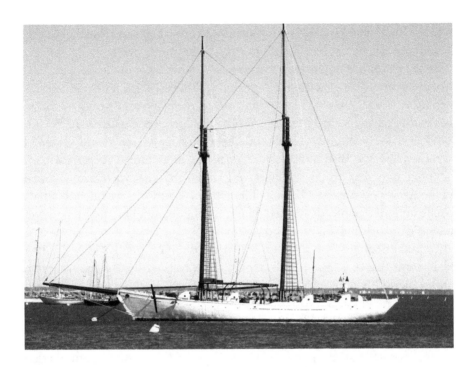

Above: Today, a more peaceful *Alabama* is moored in Vineyard Haven Harbor. *Photo by Joyce Dresser.*

Right: The *Ocmulgee* of Edgartown was the first victim of the Confederate raider *Alabam*a. *Courtesy of Connie Sanborn.*

passage for ships along the nation's waterways and shipping lanes. He was knowledgeable of the New England whaling industry.

When war broke out in 1861, Semmes was invited to join the Confederacy, where he proved an effective nautical raider. "Indeed, the lighthouse keeper's departure from the Union was proving one of the worst catastrophes to befall American maritime enterprise, the Yankee whaling fleet in particular."[83]

Semmes was named captain of the Confederate navy and assumed command of the British ship *No. 290*, which he renamed *Alabama* for his adopted state. The cruiser, 235 feet long with eight guns, was commissioned in the Azores on August 24, 1862. The crew of eighty was assigned to attack whale and merchant ships in retaliation for the scuttling of the Stone Fleet and to damage the New England economy.

Captain Semmes flew the flag of Great Britain on the *Alabama*. His first victim was the *Ocmulgee*, of Edgartown, captured, burned to the waterline and sunk on September 5, 1862. The crew of thirty-seven was unharmed but set ashore in the Azores.

The master of the *Ocmulgee* was Captain Abraham Osborn Jr. of Edgartown. Osborn was an able captain. His father was also a whaling captain with the same name. In 1860, Captain Osborn had commanded the *William Wirt* and returned to port with three thousand barrels of oil and another thirty thousand pounds of whale bone, a very successful venture.

Semmes attacked the *Ocumulgee*, "notwithstanding the fact that Captain Semmes of the *Alabama* had been a guest and broken bread at the Osborn home on South Water Street."[84] Before the war, as national lighthouse inspector, Semmes had stayed at the Osborn house, which Abraham Osborn Sr. had converted to an inn. Now, he attacked and burned and sank the *Ocmulgee*.

From his initial success in the Azores, Raphael Semmes attacked one ship after another across the North Atlantic. Whaling captains capitulated without an argument, knowing they were defenseless. "No master fought back or resisted, although some tried to talk their way out of their predicament after capture."[85] Under Captain Semmes, the *Alabama* proved a devastating force against the vulnerable whaleships.

Semmes did not ease up. He burned the *Virginia*, under Captain Shadrack Tilton of Chilmark, and the *Levi Starbuck*, under Captain Thomas Mellen of Holmes Hole. Over the subsequent nine months, the *Alabama* captured and burned sixteen whalers and forty-nine merchant ships.

When whaleship owners complained to the U.S. government about the lack of protection for their ships, the response was that it was less important

Semmes took the crew prisoner, appropriated the ship's chronometer and sank the ships, but did not harm the whalemen. *Chronometer courtesy of the New Bedford Whaling Museum; photo by Thomas Dresser.*

to protect whaleships than to hurt the cause of the Confederacy. It was not until the early summer of 1863 that the USS *Kearsarge*, charged with tracking down the *Alabama*, engaged in a vicious gun battle in the English Channel. The *Alabama* was sunk on June 19, 1863. (The wreck was discovered in 1984, seven miles off Cherbourg, by the French minesweeper *Circe*.)

In the autumn of 1863, another Confederate raider, the *Florida*, was sunk by the USS *Wachusett*. The *Wachusett* "was named after a mountainous piece of New England's granite vertebrae that rose starkly out from the low rolling green hills in the center of the Bay State."[86]

The sinking of the *Alabama* and the *Florida* did not guarantee whaleships were safe. A year later, the British ship *Sea King* set out to haunt more whaleships. England supported the Confederacy in order to maintain the flow of Southern cotton to keep British textile mills running. The *Sea King* was renamed the *Shenandoah*, and the 222-foot-long steam-sailing ship was placed under the command of Lieutenant James Waddell on October 30, 1864.

To attack the whaleships, Waddell planned to follow the whales. Whaleships gathered in the North Pacific, which is where Waddell headed. Like most Southerners, Waddell believed any ship was a target if it hailed from north of the Mason-Dixon line.

Setting off from Liverpool, the *Shenandoah* sailed around the Cape of Good Hope, off South Africa. On the way, Waddell captured the *Edward*, under Captain Charles Worth, off the island of Tristan da Cunha. (Tristan lies 1,700 miles west of Cape Town, South Africa, in the South Atlantic.)

The *Shenandoah* continued through the Indian Ocean toward Australia before heading into the North Pacific. On April 1, 1865, the *Shenandoah* sank six whalers stranded in the harbor at Ponape, then continued north of Japan into the Arctic. (Ponape or Pongee is in Micronesia, north of Australia and the Caroline Islands.) "Already the whalers were beginning to point the finger of blame for the raiders toward the island kingdom"[87] of Great Britain. The *Shenandoah* struck fear in whaling captains who sailed the North Pacific; whaleships had no means to defend against a warship.

The *Shenandoah* flew a Russian flag to deceive whaleships and wrought destruction similar to its predecessor, the *Alabama*.

As the *Shenandoah* prowled the North Pacific, whaleship captains cut short their ventures. This augmented the supply of whales, and as one wag put it, "Had the *Alabama* and *Shenandoah* never sailed, several species of whales might now be extinct."[88]

Robert E. Lee surrendered to Ulysses S. Grant on April 9, 1865, which essentially ended the Civil War. "An added touch of bitterness and irony was that the commander of the *Shenandoah* did not know when the war ended, and kept on burning whaleships long afterward."[89] Captain Waddell refused to believe the war was over.

Captain Daniel Worth and his wife, Jane, sailed aboard the *Gazelle*, whaling in the Indian Ocean near Christmas Island. They learned of the Confederate raider *Shenandoah* and the devastation it wrought in the Pacific. Fortunately, Captain Worth managed to steer clear of the *Shenandoah*, but many other captains were not so lucky.

Like Semmes, Waddell of the *Shenandoah* was intent on sinking whaleships but not harming the men themselves. "This was, of course, war most civil."[90] Waddell continued his brazen attacks well into the summer of 1865.

The *Waverly*, under Richard Holley of Edgartown, was captured and burned on June 25, 1865.

The *General Pike* was captured by the *Shenandoah* and used as a prisoner ship for captured crew. The former captain of the *Pike*, Shadrack Tilton of Chilmark, had died in February; first mate Hebron Crowell was now in charge.

The *William Thompson*, under Captain Francis Cottle Smith of Edgartown, was whaling in the North Pacific. His ship was sunk along with twenty more vessels after the end of the war.

Captain Waddell continued inflicting damage on whalers in the Pacific, capturing and burning twenty-five ships in the Arctic in 1865. For months, he refused to believe the war was over. Waddell claimed to have sunk thirty-two whaleships and merchant ships.

Eventually, someone handed Waddell a newspaper with details of the end of the war, and Waddell acknowledged the war was over. He then faced the unenviable task of defending his actions. He was no longer a Confederate navy captain; there was no Confederacy. Now he was considered a criminal, a pirate, and forbidden to enter any harbor in the United States. Eventually, he realized his only safe haven was returning to Liverpool, which he did on November 15, 1865, seven months after the war was over. The men on the *Shenandoah* fired the last shots of the Civil War.

More than seventy whaleships were lost in the Stone Fleet and to the Confederate raiders. It was a devastating blow to whaleship owners, captains and crews and caused the price of whale oil to spike dramatically by war's end.

It is worth noting that reparations were paid by Great Britain for whaleships that were destroyed—some ten years after the war. Samuel Osborn Jr., owner of the *Ocmulgee*, received $94,102 for the ship sunk when his cousin Abraham was captain.

The decimation of the whaling fleet during the Civil War included approximately thirty ships sunk in the Stone Fleet; Captain Semmes of the *Alabama* sank thirteen ships, and Captain Waddell of the *Shenandoah* captured thirty-two ships. That was at least seventy-five whaleships lost in the Civil War.

Captain Thomas Mellen (1834–1911) was born in Holmes Hole, now Vineyard Haven. He sailed aboard key vessels during a tumultuous era in the whaling industry. As captain of the *Levi Starbuck*, in 1862, Mellen's ship was attacked and burned by the Confederate raider *Alabama*. As captain of the *Europa*, Mellen rescued nearly 250 whalemen caught in the Arctic freeze of 1871. Also, Mellen was captain of the *Northern Light*, *Lucretia* and *Thrasher*.

Captain Mellen's house was at 105 Main Street, on the corner of Pease Point Way, adjacent to the Dr. Fisher mansion. While his house does not dominate the grounds as do other captains' mansions, it still holds a pivotal place in downtown Edgartown.

11

MUTINY!

Murder aboard the Globe *was "the bloodiest mutiny in whaling history."*[91]

Awhaleship was a dangerous place when disaster struck, whether caused by natural storms or tempests of human nature. It was confining, self-contained and at sea. An able-bodied captain was generally able to maneuver his ship through threatening weather and high seas with minimal damage. But even a capable captain was challenged to manage his crew amid disruptive human behavior caused by depression, delusion or dismay.

Ellsworth West was captain in three whaling voyages with the *Horatio*. When he set off from San Francisco in 1897, he planned to capture sperm and right whales in the North Pacific. His first venture was deemed successful, so he was hired for a second trip.

At sea, a weather breeder caught the *Horatio*. "Then for six hours the ship lay to under forestaysail and main spencer with the wind blowing at hurricane force and tremendous seas coming at her from every direction."[92] The drama on the open ocean continued: "Seas poured over the deck, smashing two starboard boats and carrying them away with davits, falls and blocks, the cooper's chest, gangway board and rail and everything in the two houses aft." Recovering from the storm, Captain West sailed to the coast of Japan, where he found the "whales were as thick as hairs on a dog." This second venture also proved profitable, reaping 781 barrels of sperm oil, 365 barrels of whale oil and 4,338 pounds of bone.

On his third voyage in the *Horatio*, in 1899, Ellsworth West ran aground off Kusaie Island on a narrow reef in the Pacific. (Today, the island is known as Kosrae, easternmost of the Caroline Islands, between Guam and Hawaii.) A coral reef ripped open the bow of the *Horatio*, and the ship began to fill with water. Captain West ordered the crew to abandon ship.

Kusaie natives assisted in the rescue with their dugout canoes. West's wife, Gertrude, was among the first taken ashore, salvaging the navigational equipment. Supplies were "lightered ashore." Gertrude's piano was the last item saved from the wreck. His crew managed to hoist it onto the deck and lowered it carefully into a whaleboat to be brought ashore. The loss of the *Horatio* signaled the end of Captain West's whaling career and that of the whaling industry as well.

Over the years, many a whaleship was lost at sea, although the number of shipwrecks was actually a small percentage of the total number of vessels engaged in whaling. More than 2,700 whaleships plowed the seas, and of those, a mere 3 percent were damaged beyond the point of repair. Whaling was relatively safe.

Yet there was real danger in approaching the quarry.

"We learn from Edgartown, that a vessel lately arrived there from a whaling voyage, one Marshall Jenkins, with others, being in a boat which struck a whale, she turned and bit the boat in two, took Jenkins in her mouth, and went down with him." The tale assumes an unbelievable outcome: "On her rising threw him into one part of the boat, whence he was taken on board the vessel by the crew; being much bruised—and in a fortnight after, he perfectly recovered." This story was published in the *Boston Post-Boy* on October 14, 1771, and reprinted by Alexander Starbuck in his *History of American Whale Fishery*.[93]

The following catastrophe occurred on August 20, 1851. After a whale stove two whaleboats, the crew managed to swim back to the *Ann Alexander* and clamber back aboard. Captain John Deblois decided to chase the whale, perhaps in retribution for sinking two of his whaleboats. The whale became aggressive, turned and swam toward the whaleship, crashing into the bow of the *Ann Alexander*, causing the vessel to fill with water.

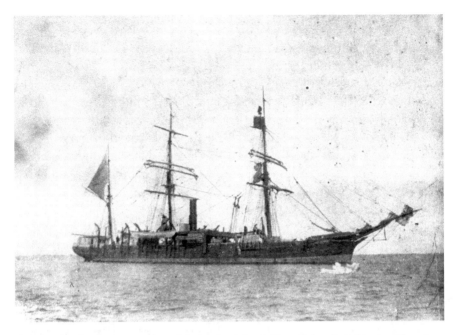

A dramatic tale of an aggressive whale involved the sinking of the whaleship *Ann Alexander* in 1851. *Courtesy of the Martha's Vineyard Museum.*

Captain Deblois managed to board his ship. He severed the masts, hoping to right the vessel, but was unsuccessful. He salvaged navigational tools, food and water, and returned to the whaleboat.

Within a short time, the whaleship *Nantucket* managed to save the crew of the *Ann Alexander*.

"James read from the *Gazette*: 'Captured at last! *Rebecca Sims*, New Bedford, captures whale five months after *Ann Alexander* was sunk, with two harpoons in him marked *Ann Alexander*." When the whale was captured, its head showed significant injuries, including wooden splinters from the ship embedded in its skull. The whale was docile and ailing; the crew of the *Rebecca Sims* took about seventy-five barrels of oil. "The wonder is they lived to tell the tale,"[94] wrote Dionis Coffin Riggs, Captain James Cleaveland's granddaughter, recalling the demise of the *Ann Alexander*.

The crew of the *Essex*, a Nantucket whaler under Captain George Pollard, endured an even more harrowing experience. The *Essex* was whaling in the South Pacific in November 1820. A sperm whale swam up and bumped the *Essex*, causing it to rock back and forth. The whale then swam ahead of the ship, turned and swam rapidly directly toward it, crashing into the bow of

the *Essex*, causing the whaleship to sink. The crew of twenty escaped in three whaleboats with minimal supplies and began to row for South America, some two thousand miles away.

The saga of survival is a heart-wrenching tale filled with human tragedy. Only one whaleboat made it to shore after three months at sea with little to no food and water. The men traveled 4,600 miles and resorted to cannibalism of five deceased crew in their desperate struggle to survive. Lots were drawn, and two more crew were sacrificed—killed, so the remaining five men could survive. Altogether, twelve men died in the ordeal. Three men were later rescued on a desert island.

Documentation of the tragedy of the *Essex* inspired Herman Melville to write *Moby-Dick.*

The *Columbia* sailed from Connecticut in 1844 under Captain Reuben Kelley. A year and a half later, after a successful whaling venture, the *Columbia* was blown ashore on a small island south of Hawaii. When the ship grounded, sailors hurried up on deck to see what had happened. Surf broke over the mizzentop. The crew cut the masts. Four whaleboats were lost in the wreck as the ship foundered. Natives approached the sinking ship and took the crew prisoner.

John Pease (1793–1879) of Chappaquiddick was captain of the *Chandler Price* on a whaling expedition. Captain Pease recognized pieces of wreckage in the ocean and realized a ship had grounded nearby.

Crewmember Thomas Crocker reported when the *Columbia* was wrecked, natives from the island held the crew hostage for three long weeks. Eventually, the *Chandler Price* approached the island. Crocker reported Captain Pease was firm and fair. He bartered with the natives to secure release of the captive crew, paying one hundred pounds of tobacco.

Despite sixteen voyages, Captain Pease was a teetotaler who neither smoked nor chewed tobacco. Pease discovered the Nomwin Islands, north of the Carolines, in the northwest Pacific, and corrected charts of the area. On retirement, he kept a hotel on North Water Street in Edgartown.

A Captain Osborn was master of the *Meridian* of Edgartown from 1828 to 1831. Osborn became too ill to go to sea, and the *Meridian* found refuge in Tarpaulin Cove, where Osborn evidently left the ship. First Officer Hiram

Fisher assumed the role of captain. Fisher proved a brutal master, yet he served as captain of the *Meridian* from 1831 to 1836, when the *Meridian* was wrecked and lost at sea.

Another whaleship, the *Wanderer*, ran aground off Martha's Vineyard in 1924. Built in 1878, the ship was moored off Cuttyhunk awaiting outfitting for a final whaling voyage. A tropical depression blew up the coastline and dashed the *Wanderer* ashore. The *Wanderer*, "tired of dragging out her days in the uncongenial atmosphere of the 20th century, at length piled up on the rocks at Cuttyhunk." When the *Wanderer* sank, "the *Morgan* was left as the sole (and inactive) survivor of a fleet which once whitened every sea."[95]

Mutinies aboard whaleships were rare. Yet on occasion, long years of isolation, loneliness, danger and deprivation incited discontented characters to precipitate a mutiny.

Aboard the *Roman*, Captain Jared Jernegan faced down a mutinous crew while his wife and children were aboard ship. Moored at Resolution Bay, in

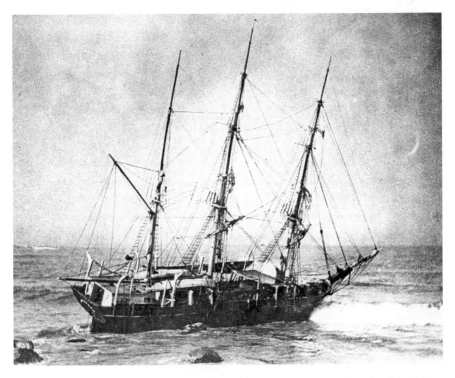

One of last remaining whaleships, the *Wanderer*, was lost in a storm off Cuttyhunk in 1924. *Courtesy of the Martha's Vineyard Museum.*

the Marquesas, seventeen inebriated sailors sought to go ashore. Captain Jernegan denied them liberty. The recalcitrant crew hoisted the first mate aloft. Jernegan locked himself in his cabin to protect his wife, Helen, and children, Laura, Marcus and Prescott.

In defiance, the mutineers lowered boats and rowed ashore. Jernegan left his cabin, lowered his first mate and set sail with his remaining crew, abandoning the unruly men. Captain Jernegan exhibited a calm presence under pressure, abandoned his derelict crew and found more willing seamen at a nearby island.

Captain Archibald Mellen was at the helm of the *Junior* with a crew of thirty-two. They left New Bedford on July 21, 1857. Cyrus Plummer instigated a mutiny with four accomplices. He had no gripe with Captain Mellen; Plummer simply wanted control of the vessel. The only way to control the *Junior* was to overpower the captain. Plummer and his accomplices murdered Captain Mellen and the third mate, then tried to sail to Australia but headed in the wrong direction.

First Mate Nelson Provost survived the mutiny by hiding in the hold for several days. When he surfaced, the mutineers forced him to navigate the *Junior* toward Sydney, Australia; there, the mutineers were captured. Provost assumed the role of captain of the *Junior* and returned the ship to New Bedford "clean," meaning it had no oil on board.

Captain Ellsworth West realized whaling in the Arctic was not an easy venture. He acknowledged that

> *always on board a whaler there were problems of discontent, discomfort and monotony, but here in the Arctic these were increased by the perpetual cold, the bleak winds, the gray, gloomy skies, and the grim knowledge that we were in for six months of the same without relief. In order to prevent mutiny, desertion and other crimes it was necessary to maintain strict discipline.*[96]

Discipline had to be fair and equitable, or discontent could exacerbate the situation.

Disease. Mutiny. Desertion. Death. There were many ways desperate men faced an intolerable journey. "In 1842, for example, a young whaleman

A painting of Captain Thomas Worth of the *Globe* hangs in the Martha's Vineyard Museum. *Courtesy of the Martha's Vineyard Museum.*

deserted from the *Acushnet* at Nuku Hiva in the Marquesas. His name was Herman Melville, and his fictional account, *Typee* (published in 1846), was a bestseller in its day."[97]

The most frightening situation aboard ship arose when the crew disliked the captain so much they instigated a mutiny. A brutal mutiny occurred on the cusp of the glory days of whaling, in 1824, when a malcontented seaman convinced accomplices to murder the captain and first mate.

Thomas Worth was hired as the captain of the ill-fated ship *Globe*. "The man looking out across two centuries is wearing a dark coat over a white shirt with a white cravat fastened down by an azure spick-pin. A telescope, the sea captain's emblem, is tucked under his left arm."[98] With his whaleship experience as first mate and reputation as a strict disciplinarian, Worth projected an image of an admirable whaling captain.

Thomas Worth was born in Edgartown in 1793, the son of Jethro Worth. He grew up in a family both prosperous and numerous on the Vineyard. Worth was first commissioned as a captain on the whaleship *Globe*. He married a local woman, Hannah Mayhew, in 1822, shortly before the *Globe* set sail on its ill-starred voyage. (Another Thomas Worth of Edgartown, likely a cousin, was a whaling captain whose son, William, was a major general for whom Fort Worth, Texas, was named.)

Captain Thomas Worth, age twenty-nine, was considered "a seasoned sailor and a stern disciplinarian," according to the *Vineyard Gazette*. After a series of delays, the *Globe* set forth on an expedition out of Edgartown on December 15, 1822.

Samuel Comstock, age twenty, from Nantucket, a boatsteerer-harpooner, dined with the officers and captain. "Comstock possessed the swarthy toughness of a veteran whaler." The *Gazette* article continued: "It soon became obvious to the rest of the crew that the brawny and aggressive Comstock was the captain's favorite." However, Comstock secretly wanted to set himself up as a king of a remote South Sea island. Crew members William Lay and Cyrus Hussey kept journals, and each penned an account of what happened aboard the *Globe*.

The impetus for mutiny was reached after a year at sea when the *Globe* chased whales from Japan to the Sandwich Islands (Hawaii), where "all the ingredients for insurrection were there. The crew had experienced indifferent success, bad food, capricious exercise of authority by an inexperienced captain, bullying and physical beatings from the officers, long confinement aboard ship with no liberty, and the concerted, pernicious influence of a malcontent."[99] Long hours with nothing to do and isolated, uncomfortable conditions added to the dissatisfaction of the crew.

The whaling expedition had not been successful, rations were low and six men deserted when the *Globe* reached Hawaii. Discipline issues threatened the voyage. New crew were recruited and provisions purchased, and the *Globe* sailed south.

On January 26, 1824, four men, recent recruits in Hawaii, accompanied Samuel Comstock on his mutinous deed. In the captain's quarters, "Comstock approached him [Captain Worth] with the axe struck him a blow upon the head." Worth died instantly. Next, Comstock shot the door where the mates bunked. Comstock "managed to strike him [First Mate William Beetle] a blow upon the head, which fractured his skull."

Comstock proceeded to make "preparations for attacking the second and third mates, Mr. Fisher and Mr. Lumbert." It was a violent confrontation. With a bayonet, "Comstock immediately ran Mr. Lumbert through the body several times!" Then he shot him. Captain Worth and three officers were killed in the mutiny.

Comstock was quoted as saying, "I am a bloody man! I have a bloody hand and will be avenged!" Comstock commandeered the *Globe* and sailed to the Mulgrave Islands, where he planned to establish an island kingdom.

The Vineyard boatsteerer Gilbert Smith and five members of the crew managed to sail off in the *Globe*, abandoning the mutineers and some crew.

On Mili Atoll, Comstock "was fated to be killed by his own mutinous confederates." He turned against his compatriots; they shot and killed him. "Thus ended the life of perhaps as cruel, bloodthirsty, and vindictive a being as ever bore the form of humanity." Natives killed several remaining crew, including Roland Jones of Edgartown. Lay and Hussey, the journalists, lived with the natives for nearly two years before their rescue by the *Dolphin* on November 21, 1825.

Demons of the Waters is an account of a mutiny aboard the whaleship *Globe* based on the recovered diary of Augustus Strong aboard the *Dolphin*. The mutiny was a savage and violent affair. Of the thirteen men murdered, seven were from the Vineyard.

News of the mutiny filtered out slowly. Residents of Nantucket and Martha's Vineyard heard rumors but could not know the details of the horrendous murders. The news was grim. Axe murders of the captain and mates and beating deaths were frightful. Relatives of the victims suffered, not knowing what had happened for many, many months.

The *Globe* returned to Edgartown on November 14, 1824, ten months after the mutiny, two years after setting sail. The widow of Thomas Worth, Hannah, incurred debts due to the death of her husband. She begged the court for leniency. Five years after the mutiny, she married Worth's brother John.

The leader of the mutiny, Nantucketer Samuel Comstock, suffered mixed personality disorders ranging from paranoia to narcissism to antisocial behavior. His activities upset everyone else, but he believed he was normal.

In the history of whaling, the *Globe* mutiny of 1824 resulted in the most carnage with thirteen deaths.

Captain Howes Norris was born in Eastville, part of Oak Bluffs. Norris married Elwina Smith, daughter of Nathan Smith, proprietor of Smith's Tavern in Holmes Hole. By 1842, Norris had three children with Elwina, and she was pregnant.

Norris was an experienced whaleman. As such, he was signed on as captain of the *Sharon*. The *Sharon* was built in the same shipyard and to the

same dimensions as the *Acushnet*, the whaleship Herman Melville crewed on in 1841. Both ships were 105 feet long, 28 feet wide, with a draught of 14 feet and a capacity for three thousand barrels of oil. Both ships were square rigged with a crew of thirty.

Captain Norris appointed his brother-in-law Nathan Smith Jr., age twenty-five, as second mate. First mate was Nathan's cousin and experienced whaleman Thomas Smith, who stood but four feet, nine inches. The rest of the crew was drawn from a variety of New England communities, including Andrew White, the cooper, of Rhode Island and Benjamin Clough, third mate, from Maine.

The *Sharon* set sail on May 25, 1841, from Fairhaven, adjacent to New Bedford, a city that boasted a population of twenty thousand and "proclaimed to be the most prosperous city of its size in the world—prosperous on whale oil and whalebone that Massachusetts ships had harvested."[100] It was the peak of the whaling era.

The *Sharon* sailed around Cape of Good Hope, into the western Pacific, on a route similar to that of the fictitious Captain Ahab and the *Pequod* of *Moby-Dick* fame.

Once at sea, Captain Norris exhibited irrational behavior such as randomly beating members of the crew for minor infractions. Often, Norris was drunk. Beginning in December 1841, Captain Norris began to systematically beat and flog the cook, George Babcock, a black man, possibly a runaway slave. The incidents began when Babcock was punished and the crew supported him. Norris had the crew thrown in irons and subsequently beat Babcock on a regular basis.

During a gam, Captain Charles Downs witnessed food tossed overboard from the *Sharon* and told Captain Norris. The crew wasted rations in order to return home sooner. In retaliation, Norris restricted rations.

In April 1842, after nearly a year at sea, nine crewmen deserted at Rotuma (Grenville Island) in the Pacific. In the *Sharon* log, Captain Norris wrote simply, "anchored at Rottunak. Men deserted."

Over a period of months, Captain Norris continued to starve and brutally beat George Babcock. Neither mates nor crew dared intervene. Babcock was denied food and ruthlessly punished without cause.

Third Mate Benjamin Clough, age twenty-two, kept a journal. He noted, "From the first of July to the first of September he beat him almost every day, using any weapon that came to hand."

Captain Norris recorded in the log on July 5: "No whales to be found and I am allmost discouraged." Day after day, he reported, "Saw nothing."

Day after day he beat George Babcock.

Judy Druett wrote an account of the mutiny, *In the Wake of Madness.* She believed that "racism certainly did exist and could well have been an element in Norris' appalling mistreatment of Babcock."[101]

The final flogging took place on the first of September. George Babcock succumbed and was buried at sea. Clough concluded in his journal, "So ends as cold-blooded a murder as was ever recorded, being about eight months taking his life."

The log of the *Sharon* for Thursday September 1, 1842, read, "[A]t 9 am George Babcock died very suddenly he complained of having the cramp." Norris had killed Babcock and blandly noted in the log that the cook had died.

Babcock's murder precipitated the mutiny.

On October 15, on Ascension Island, now Pohnpe, in the Northwest Pacific, twelve more men deserted, refusing to remain aboard with a murderer. This left the *Sharon* seriously undermanned, with only seventeen aboard ship. Captain Norris headed to New Zealand to recruit more crew.

By 9:00 a.m. on November 6, 1842, Captain Norris was already drinking heavily. At 3:00 p.m., the crew spotted whales, and Norris ordered two whaleboats lowered with six men in each. That left only five men aboard ship. Two were Hope Islanders recruited in April to replace the deserters. They had been beaten by Norris as well and feared he would kill them, too. One was an Ocean Islander, George Black, the cook who replaced the deceased Babcock. The fourth was a cabin boy, Manuel dos Reis, picked up in the Azores. The fifth man was Captain Norris.

The two whaleboats successfully chased and caught a whale.

The Hope Islanders, fearing for their own lives and armed with a cutlass and a cutting spade, brutally attacked and killed the captain.

The boy, Manuel dos Reis, climbed the rigging and inverted the ship's flag to signal distress. The whaleboats spotted the ship's upside-down flag and turned back. They realized the crew had slain the captain and were trying to sail away from the whaleboats.

Knowing the whaleboats were unable to make the seven-hundred-mile trek to the nearest land, the crew followed the *Sharon.* That night, Third Mate Benjamin Clough dove out of the whaleboat and swam to the *Sharon.* As he documented, "I took the boat knife in my mouth as A weapon against sharks as there was A great number around and droped silently overboard and swam for the head of the ship." Clough slithered through a cabin window.

A second account was recorded by Andrew White, the cooper: "The Boat pulled out head of the ship and the third mate got overboard and swam to the ship and got in the cabbing winders at the same time one of the boats kept a stern of the ship to pick up the third mate if he did not succeed in getting into the winder."[102]

Years later, in the obituary of Benjamin Clough, in 1896, the *Vineyard Gazette* summarized Clough's daring effort to retake the ship: "Dropping overboard from one of the boats, after swimming for an hour and a half he climbed into the cabin window, and single-handed encountered the natives and re-took the ship."[103]

Benjamin Clough overpowered the first Hope Islander and shot and killed the second. He waved the whaleboats back to the *Sharon*. The date was November 6, 1842.

Manuel dos Reis was commended for alerting the whaleboats. Thomas Smith assumed the role of captain, Nathan Smith was first mate and Benjamin Clough became second mate. The cook, George Black, remained concealed aboard ship for a day and was taken prisoner but later freed.

The *Sharon* "put into Sydney December 22, 1842, the crew having mutinied and killed Captain Norris."[104] Captain Thomas Smith kept the *Sharon* at sea and returned to New Bedford on February 10, 1845, two years after the mutiny. The *Sharon* unloaded 900 barrels of sperm oil, 1,050 barrels of whale oil and 9,000 pounds of whalebone, a successful venture under gruesome circumstances.

Within three months of returning home, the *Sharon* set sail once more, now with Benjamin Clough as master and Andrew White as cooper and shopkeeper.

Benjamin Clough and Andrew White each maintained journals of the activities aboard the *Sharon*. Clough even painted a watercolor image of the scene. Neither the Smith cousins, Clough nor White ever publicly told the story of the psychopathic behavior exhibited by Howes Norris. Their journals were uncovered and parsed for the grim details of this tale much later.

Benjamin Clough (1819–1889) married Charlotte Chase Downs, daughter of Captain Downs of Martha's Vineyard. (Downs was the captain who had alerted Captain Norris of the *Sharon* crew tossing rations overboard.) As a whaling captain, Benjamin Clough grossed $100,000 on the *Niagara* in 1851 and over his career realized more than $400,000. Clough became an upstanding member of the Vineyard community. Three great-grandsons of Benjamin Clough, Marston, Bradford and John,

treasure their ancestor's heroics. Marston Clough is a popular Vineyard watercolor artist. Benjamin Clough's watercolor of the mutiny is not in their possession.

Howes Norris's wife, Elwina (1814–1851), died tragically when struck by lightning. Nathan Smith Jr., second mate, prospected for gold in California and died in 1868. First mate/cousin Thomas Smith served as captain of the *Mary Francis* and enjoyed a successful nautical career. Cooper Andrew White died in 1896 at age eighty-one. He never spoke publicly about the brutality he witnessed.

Scenes from the mutiny aboard the *Sharon* sound eerily familiar to the atmosphere that unfolded aboard the *Pequod* in *Moby-Dick*.

Captain Jared Jernegan (1825–1899) had a long and storied career as a whaling captain and was the father of diarist Laura Jernegan, the girl on a whaleship. From 1850 to 1886, Jernegan's name surfaces frequently in the annals of Edgartown whalers. He went to sea as a cabin boy at thirteen, was

Captain Jared Jernegan's home at 33 South Summer Street is adjacent to the Charlotte Inn, former home of Samuel Osborn Jr. *Photo by Joyce Dresser.*

made master at age twenty-six and often threatened that each voyage would be his last but kept whaling for nearly half a century. Jernegan was captain of the *William Thompson*, *Oriole* and *Roman*, lost in the Arctic freeze of 1871. He was also master of the *Napoleon* out of Edgartown and the *Europa*.

Jernegan's house is across the street from the office of the *Vineyard Gazette*. His brother Nathan's home was at 68 School Street, a couple of blocks away.

At the end of his life, Jernegan was tainted by the miscreant activities of his son Prescott, who sailed with the family as a boy aboard the *Roman*. As a Baptist minister, Prescott colluded with the son of another Edgartown whaling captain, Charles Fisher. Together, they convinced gullible investors to part with their monies in a scam to make gold out of salt water.

12

WHALING IN ICE

The Arctic is unforgiving. "Any Arctic whaleman will tell you that when a man goes into the Arctic he is a total stranger to conditions every year. The land, naturally, is well anchored and don't shift, but that's the only thing that don't vary. In thirty-two years that I spent in the Arctic, I have never seen two summers alike as regards to ice."[105]

After the Civil War, the whaling industry underwent a significant realignment.

Fashion played a part. Even as whale oil lost market value, the price of whalebone increased. Whalebone or baleen could be fashioned into innumerable items, from the heads of canes to women's corsets. Baleen, from the bowhead whale, was a precursor to plastic: it was pliable, strong and adaptable to multiple purposes. Switching from oil to bone changed the focus of whaleship enterprises.

A precipitous event further impacted sperm oil: the invention of the electric light bulb by Thomas Edison in 1879. Now a constant, reliable, efficient illuminant was readily available without the concomitant dangers of chasing whales. The electric light bulb proved an effective alternative to whale oil.

As the Atlantic was overfished, whaleships of the late eighteenth century expanded into the Pacific. Whaleships of the mid-nineteenth century discovered fertile whaling grounds in the waters of the Arctic and the hunt for whalebone.

Thomas Welcome Roys of Sag Harbor, Long Island, captain of the *Superior*, led the first whaleship through the Bering Strait on July 23, 1848. It was possible to sail north within the confines of the narrow inlet between Alaska and Russia. Roys sailed in the summer. His crew was fearful of pushing the boundaries, but Roys proved he could successfully chase and capture whales in the Arctic.

Within two years, dozens of whaleships followed the *Superior*, chasing bowheads for their baleen. Hunting whales in the Arctic proved successful—but only in the summer months. The *Citizen* whaleship did spend a winter in the Arctic Ocean in 1856, but that was unusual. Whaleship captains learned to recognize the inherent dangers of Arctic whaling. They understood that frozen ice floes and even glaciers could impede whaling. Whalemen were a brave lot, however, and each captain who ventured through the Bering Strait cautiously determined to make his voyage a success by not becoming trapped by ice.

Since 1850, San Francisco had become a key port for Pacific whaleships. San Francisco was the nexus of whaleships heading out to chase sperm whales in the Pacific and, later, bowheads in the Arctic. By the 1880s, San Francisco had replaced New Bedford as the center of the American whaling industry.

The bowhead whale swims with its mouth open, collecting fish, then closes its mouth like a sieve and swallows the fish. Bones in the mouth are made of baleen, a substance similar to fingernails. It is pliable, like plastic, and was used for a multitude of items in the late nineteenth century. A typical bowhead could render a ton of whalebone—including whale oil. Between oil and baleen, a single bowhead whale could generate $11,000.

Bowheads live in the Arctic, which made Arctic whaling the next frontier of the whaling industry. Changing the product harvested from a whale kept the industry vibrant. In the last quarter of the nineteenth century, the whaling industry adapted to a new paradigm, a new environment, to capture whales. As the market for sperm oil declined, whalebone or baleen became the primary source of revenue through the end of the nineteenth century.

Bowheads were not fighting whales, like sperm whales. Generally, whalemen would use a bomb gun to stun and kill the bowhead instead of

Left: The captain and his mates dined below deck on the *Charles W. Morgan* at Mystic Seaport. *Photo by Joyce Dresser.*

Right: The first mate kept the log and bunked by the dining area. *Photo by Joyce Dresser.*

a harpoon. The dynamite-filled cartridge was placed in the harpoon and exploded in the blubber, causing instant death. Then the profits were there to be plucked from the carcass.

Bowhead whales were the most popular product garnered from whaling in the last quarter of the nineteenth century. "The Arctic bowhead whales were the most valuable, yielding whalebone of finest quality…thickly covered with blubber that yielded a large quantity of oil."[106] Blubber in the tongue could be two feet thick, which would yield a couple dozen barrels of oil by itself. It was a profitable enterprise. And over time, whalebone proved more valuable than whale oil.

Of a specific bowhead, Captain Ellsworth West remarked that it "was one of the largest bowheads I ever saw. He made 2700 pounds of bone and 130 barrels of oil, which was worth between eight and nine thousand dollars that fall when we put in to San Francisco."[107]

Tides in the Arctic, agitated by the wind, caused ice floes to drift. Ice was a condition whalemen had to contend with, learning to maneuver

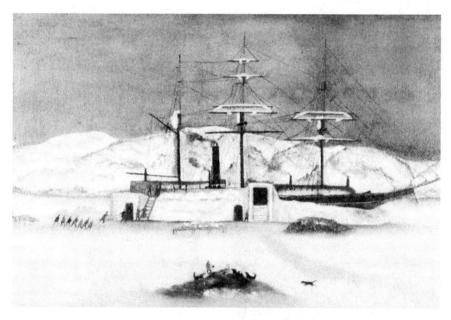

The Arctic Ocean presented a unique set of circumstances for the whaleships. This is the *Belvedere* wintering over in the Arctic. *Courtesy of the Martha's Vineyard Museum.*

around great ice floes, working their ships as far north as possible without endangering their very survival.

In the Arctic, scurvy was dangerous, as there was little or no fresh food. Captain Bodfish of Vineyard Haven advocated more fresh meat for his crew but lacked a clear plan on how to find it. In Iceland, whalemen combated scurvy with lichen, which contains ascorbic acid. Lichen became known as the whaleman's cabbage.

Working on deck in freezing conditions often resulted in frostbite. If soaking the affected finger or toe in ice water did not relieve the frost, the digit might have to be amputated. And sailors learned to wear smoked glasses to ease the pain from the glare of the sun on snow, which caused snow blindness.

The most worrisome aspect of whaling in the Arctic was fear of the unknown. In the twenty years since the first whalers ventured into the Bering Strait, it was believed to be safe to go whaling in the summer. A few brave souls wintered over in the Arctic, but the majority of whalers worked from June through September, then headed south. Ice was the great unknown; it moved and expanded and crunched and heaved and groaned depending on tides, temperature, humidity, currents and wind.

Still, most captains felt comfortable whaling in the Arctic throughout the summer.

The summer of 1871 proved that theory wrong.

That summer, an "icy embrace" crushed and sank dozens of whaleships, devastating the New Bedford whaling industry. However, not a single life was lost in this calamity. The Arctic freeze of 1871 destroyed thirty-three whaleships. Another dozen were lost five years later in a similar freeze-in. The loss of forty-five whaleships was a significant blow to whaling communities, especially New Bedford. Martha's Vineyard only lost two ships, the *Mary* and the *Contest*, although many island captains, masters of ships from Nantucket or New Bedford, were caught in the Arctic freeze.

In early August 1871, three dozen whaleships continued whaling north of the Bering Strait, attempting to reach Point Barrow within the Arctic Circle, said to be ripe with bowheads. The wind shifted to the northwest on August 11, and the ice expanded toward shore with loud crunching sounds, surrounding twenty ships. Thirteen whaleships were in the vicinity but near open water.

By mid-August, the ice was forming faster and more extensively than any captain had ever experienced. Whaling was good, but the weather was ominous. Local natives, the Inuit, warned the whalers of impending freezes. Yet the whaling was good, and it was still only late summer.

By August 25, the ice was broader and thicker.

Ice floes stood thirty-five to fifty feet out of the water, with much more below the surface. "In all that day [August 28, 1871], some thirty-two ships were locked in the ice, with one unfortunate trip of whalers caught in the pack too close together to even swing at their cables."[108]

Four days later, heavy drift ice hoisted the *Roman* cleanly out of the water. "Three times the ice contracted and relaxed, acting like a massive hammer on an anvil, stoving in her side and finally smashing her to 'atoms.'"[109] Captain Jared Jernegan did all he could to rescue his crew. The *Roman* was crushed by the ice and abandoned.

The *Oriole* was next. Under Captain Henry S. Hayes, the *Oriole* ran into a submerged ice floe that crushed his ship; it was condemned. The *Champion*,

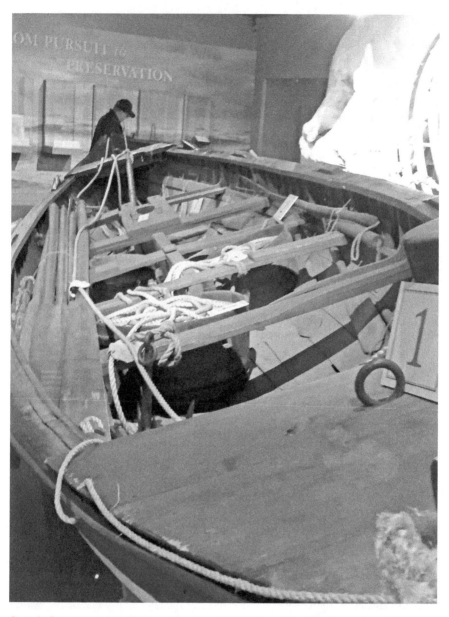

Captain Jernegan assigned sixteen men to each whaleboat. The boats were dragged across the ice to safety. *Courtesy of the New Bedford Whaling Museum; photo by Thomas Dresser.*

from Edgartown, under Captain Henry Pease, was caught in the freeze-in and abandoned.

Over the next ten days, the ice encased twenty-nine whaleships, precluding escape, and virtually sentencing the crews and family members, which numbered over 1,200, to certain death if they remained.

At Point Belcher, the thirty-three masters met and agreed they had to abandon their ships to escape. They signed a document that read in part: "We feel ourselves under the painful necessity of abandoning our vessels, and trying to work our way south with our boats, and, if possible, get on board of ships that are south of the ice."[110] Rescuing the crew and passengers preempted pursuing whaling profits.

Men, women, children and provisions were loaded into whaleboats and rowed away from their respective whaleships on September 12, 1871. Four ships had already been crushed. The plan was to row south seventy-five miles to Icy Cape, then crowd aboard those few whaleships still free of the ice. "This was the greatest and most costly defeat to maritime enterprise yet."[111] It was a brave, terrifying, decision, but it saved lives.

As the 1,200 survivors rowed their whaleboats against a "harsh wind, the mariners discovered the progress and power of the ice were worse than they'd guessed. Had they idled longer, the ice might have kept even their whaleboats from passing."[112] The immediate threat was that the ships would become entombed in the ice, crushed and sunk without the opportunity to escape. They felt they had made the right choice to abandon their whaleships.

The *Europa*, under captain Thomas Mellen of Edgartown, was one of the ships in the southern fleet that rescued those from the north. Having encountered ice, Mellen relinquished his whaling venture and, without hesitation, allowed crew from abandoned whaleships to board his ship. The 1,200 people were rescued by their fellow whaleships and set sail for Hawaii, which they reached on October 23. The evacuation saved the lives of 1,219 men, women and children but cost the whaling industry thirty-three whaleships, as well as the anticipated profits of the season.

The port of New Bedford lost more than twenty whaleships, which decimated its fleet. Only seven ships managed to escape the encroaching ice packs.

Public response to the rescue effort was praiseworthy, although it did nothing to replenish the coffers of the whaleship owners or the crew or captains themselves, who suffered financial reverses in the Arctic freeze. "November 10, 1871: For a time it seemed almost impossible to realize the

magnitude of the catastrophe which has destroyed so much property, and deprived of business 1,200 men, including many of our most enterprising Vineyard whalemen. The one great cause for congratulation is that no lives were lost."[113] All 1,219 men, women and children were saved.

Of the various ships, the *Europa* rescued stranded whalemen and had about three hundred barrels of whale oil. From the Vineyard, two ships were crushed and sunk. The *Mary* was only partially insured and crushed, along with the *Champion*. Many Vineyarders were involved in the Arctic freeze in addition to the *Roman*'s Captain Jared Jernegan: Abraham Osborn Jr. of the *George*, Henry F. Worth of the *Gay Head*, Ariel Norton of the *Awashonks*, West Mitchell of the *Massachusetts* and Captain Leander Owen of the *Contest*. Numerous Vineyard mates and crew were also involved in the catastrophe.

The effects of the freeze were magnified over the years. As whaling was decimated by losses sustained during the Civil War and the Arctic freeze, the economy of Martha's Vineyard suffered. "When the whaling business ended, Edgartown fell into an economic decline."[114]

The Arctic freeze precipitated an end to the most profligate and profitable whaling operations. The results of the calamity were felt halfway around the world, back on Martha's Vineyard:

> *Edgartown, the shire town at the eastern end of the Island, was in deep decline. Its major business, whaling, had moved to the Pacific. The town's leading businessman, Sam Osborn Jr., was still sending out small whalers, mostly schooners, into the Atlantic to provide his refinery and candle works with oil. But it was a small operation.*[115]

In the autumn of 1874, Professor Nathaniel Southgate Shaler described the local devastation wrought by the freeze-in a world away:

> *These comfortable homes, like those of New Bedford, mark a period of prosperity which has passed never to return. Little by little the population is drifting away; some houses stand empty, and the quick agent of decay which makes havoc with our frail New England houses will soon be at work at them, and even the Yankee thrift cannot keep it away.*[116]

The people of Edgartown embarked on a different economic strategy. Distancing themselves from the rigors and dangers of whaling, businessmen promoted tourism as the road to success. Beginning in 1874, the Martha's Vineyard Railroad brought tourists from Oak Bluffs to Edgartown and on to Katama. Seven large hotels sprang up in Oak Bluffs, and the imposing Harbor View Hotel of Edgartown opened its doors in 1891. Tourism gradually succeeded whaling, but the majesty and romance of whaling lingered on through the years.

Whaling activity by sturdy Vineyarders did not end with the end of the century. Well into the first two decades of the twentieth century, whaleships continued to depart ports bound for the Arctic, with Vineyard captains at the helm. Profits were no longer substantial, crews were reduced and the impact on the economy was severe.

In 2016, after a twenty-year search, the remains of two whaleships lost in the Arctic freeze of 1871 were discovered. "Nearly 144 years after they sunk in the ice off the Arctic coast of Alaska, NOAA (National Oceanic and Atmospheric Administration) maritime archaeologists reported finding the battered hulls of two 1800s-era whaling ships and what appear to be parts of others."[117] Underwater videos of the ships depict decking, an anchor, rigging remains and ballast stones.

Due to climate change, there is less ice in the Arctic. This allows underwater archaeologists equipped with modern sensor and sonar technology to ascertain the location of these wrecked ships, which apparently settled on a sandbar off shore. Thus concludes this final chapter of a dramatic whaling saga.

A most dramatic situation unfolded in the autumn of 1897. Whaleman George Fred Tilton of Chilmark found himself aboard the whaleship *Belvedere*, iced in along with two other ships in the crushing ice floes north of Alaska. The *Belvedere*, *Orca* and the *Freeman* were trapped. Crewmen from the three vessels faced certain death unless help arrived before their food ran out. George Fred Tilton volunteered to seek help. *Belvedere* captain Joseph Whiteside gave permission.

George Fred Tilton walked more than 1,700 miles along the ice around the Alaskan coastline to seek help. He had two natives with dogsled teams

accompanying him. Tilton set out from Point Barrow, along the coast of northern Alaska, on October 23, 1897. Of his venture, he wrote, "I figure [it] is the only one of its kind on record, that is, walking back from a whaling voyage."[118] He made it to Kodiak Island, along the south shore of Alaska, and sailed on to Portland, Oregon, traversing some 1,700 miles along the coast, reaching his destination on March 17, 1898.

One phrase captures the drama of the journey. Tilton described a winter storm he and his guides encountered: "[B]y this time a regular blizzard was raging an old twister that made a man wish that he was rigged like a turtle."[119]

When he reached San Francisco, no one believed he had made the trek. Tilton was proclaimed a hero. A second man left the frozen vessels at the same time, seeking help. Charles Walker traveled along a faster route via Herschel Island. Walker, however, spent considerable time drinking and carousing along the way and reached his destination within days of Tilton, who endured a much more rigorous route.

As for the crew of the stranded ice-bound ships, local Inuit guided a herd of caribou in their direction to feed the men, and all were saved.

Edwin Coffin Jr. of Edgartown was captain of the *America*, which set off in 1903 trying to beat naval officer Robert Peary to the North Pole.

For his effort to reach the North Pole, the financier William Ziegler, known as the "baking powder king," "decided to hire American whalemen more familiar with the polar ice north of the Arctic Circle." Edwin Coffin Jr. was chosen to lead the expedition. The *New Bedford Standard* commended Coffin as one of "few local men [who] have had as much hard ice navigation and few are as daring."[120] The *Vineyard Gazette* observed that Coffin received a "very handsome compensation" of $150 per month. Photographer Anthony Fiala named himself commander of the expedition.

George Fred Tilton was offered co-captain but turned it down. "Like his friend Edwin, Captain Tilton was not seeking adventure or glory. He had gotten enough of both in 1897 when he made a five month trek across the ice and snow from Point Barrow, Alaska to Seattle, carrying news of the desperate plight of the whaling fleet iced in there. The trip made him a celebrity."[121]

Under Edwin Coffin, the *America* took on six hundred tons of coal and headed for Franz Josef Land, northeast of Norway. Captain Coffin braved ice and fog and had to ration coal and water. Coffin led the *America* to within about five hundred miles of the North Pole before he had to retreat. The most northern point the *America* reached was on August 31, 1903, at eighty-two degrees.[122] Six years later, Robert Peary successfully reached the pole on April 6, 1909, although it was later determined he was still sixty miles away.

There were still a lot of whales in the Arctic.

The *Bow Head II* steamed out of San Francisco on March 17, 1908, under Captain James Tilton. The boat started leaking, so the crew manned the pumps. Two days later, on March 19, the log noted that "the steward very sick with alcoholism. The engine broke down at 8:30 pm. Put the steward in irons and put a man to watch him." Nevertheless, Captain Tilton persisted on a six-month crises-filled cruise and returned to port with a significant profit.[123]

In a 1908, Captain and Mrs. James Tilton of Middle Road, Chilmark, posed for a photograph. "He is dressed in the 'uniform' of the successful whaling master: top hat, Prince Albert jacket, striped trousers and a thick gold watch chain." Over the years, Tilton was master of several whalers. He was best known as captain of the *Bow Head II* (1903–6 and again in 1908), out of San Francisco, after which he retired. James Tilton was a cousin of George Fred Tilton; both men served as masters of the steam whaler *Bow Head II*.

Captain Charles Fisher had a house at 22 North Water Street, on the corner of Winter Street, built in 1892. Fisher's son colluded with Prescott Jernegan to dupe gullible investors in a scheme that converted salt water into gold.

Fisher claimed he had captured the largest sperm whale ever recorded in 1884 as captain of the *Alaska*, a bark out of New Bedford. He sailed

on a half-dozen voyages aboard the *Alaska* between 1871 and 1891 and continued sailing into the Arctic until 1905 aboard the *Josephine*, the *California*, the *Canton II*, the *Alice Knowles* and the *Gay Head II*, which he commanded on five voyages.

THE ROMANCE OF WHALING

*The center of the industry was always that small area that included
the Islands of Martha's Vineyard and Nantucket.*[124]

Life at sea, for years at a time, was certainly not an easy career to
embark on, and whalemen paid the price. Poor diets and unsanitary
living conditions contributed to a stunted lifestyle. It was "no wonder men
turned to scrimshaw, sea chanteys, and dancing the sailor's hornpipe to add
touches, however slight, of gentility to their totally male-oriented lives."[125]

Whaling evolved as a viable economic business along the shores of
southeastern Massachusetts, as historian/musician Gale Huntington noted
in his landmark book, *Songs the Whalemen Sang.* He observed that small whaling
operations emerged from the coastal towns of Cape Cod and the islands
to become the center of the industry worldwide. And whaling chanteys or
songs were a mainstay in the viability of whaling operations.

Huntington's book documents songs that evolved from the whaling
industry. "A majority of the songs in Huntington's book relate to work on
whaling ships, from hauling a whale carcass aboard ship to hoisting a sail or
raising an anchor."[126] The intent of the songs was not to create harmonious

sounds but to ease the physical travails associated with whaling by singing a simple song together. On occasion, sailors would break into song or perhaps dance a reel to relieve the monotony of being aboard ship. Dancing and singing were energetic and harmless ways to release tension from long days, weeks and months.

Huntington explored the background of the songs the whalemen sang. He found that "music—song—was one of the very few real pleasures that whalemen had."[127] The whaleman's work was challenging and dangerous and difficult or slow, boring and tedious. Songs brightened the workload and made working together more tolerable. Expressing oneself in song provided a brief respite, a means to escape, however temporary, from the rigors of the world of whaling.

The Whalers' Song

There she lies there she lies
Like an isle on ocean's breast
Where away west south west
Where the billows meet the skies
Port the helm trim the sail
Let us share this mighty whale
There she blows there she blows

A second volume of songs, again assembled by Gale Huntington, was published posthumously. *The Gam: More Songs the Whalemen Sang*, was intended to be a sequel to *Songs the Whalemen Sang*. This tome was based on a collection of songs recorded in a journal kept by Sam Mingo, a Christiantown Wampanoag aboard the *Andrew Hicks*, a whaleship that sailed from 1879 to 1881 under Captain Edward Hicks. Huntington borrowed Mingo's journal, copied the chantey lyrics and returned the volume.

Sam Mingo's daughter Addie inherited the journal. Addie married Amos Smalley, the Gay Head whaleman who harpooned a white whale in 1902. The couple had no children, and when Amos and Addie passed away, all their possessions, presumably including the journal, were discarded in the Gay Head dump. Thus, Huntington's foresight in copying the lyrics preserved them.

Gale Huntington's wife, Mildred, was the granddaughter of Welcome Tilton, one of seven brothers who grew up on North Road in Chilmark in the mid-nineteenth century. They were hardworking locals who burnished

their musical talent throughout their lives and were known as the Singing Tiltons. The brothers were William, Welcome, Alton, Zeb, Edward, George Fred and John. All of them sang.

Welcome Tilton was the progenitor of many of the songs recorded in Huntington's books. Welcome's brother George Fred "couldn't carry a tune [so] his singing was often more than slightly painful. Most of his whaling was for bowheads in the Arctic."[128] Of the song "Little Brown Jug," Huntington wrote, "George Fred Tilton, who sang the song, was the most famous of the Tilton brothers because of his long walk home from the Arctic to report that the whaling fleet, frozen in the ice, was running low on food. *Little Brown Jug* was George Fred's favorite song, and he liked what was in the jug, too."[129]

Come All That Sail from Edgartown

On February the twenty-seventh
That day I still bewail
On board a south sea whaling ship
From the Vineyard we set sail
To gain an offing from the land
That night in vain we strove
We stretched across the Vineyard Sound
And anchored in the Cove

"The Cove" refers to Tarpaulin Cove off Naushon Island in Vineyard Sound. Tarpaulin Cove was a popular anchorage for whaleships awaiting a good wind.

On a much more somber note, there was often a death at sea.

Bury the Dead

The last sad rites are paid to him
The sea receives the dead
The ocean bird with heavy wing
Still flutters o'ver his head.

This song was sung aboard the bark *Lexington* under Captain Hilliard Mayhew, who hailed from Quitsa, in Chilmark, on his sole, and unsuccessful, whaling voyage in 1853.

Whaling chanteys were not composed for the musical elite—nor were they considered proper music to be performed before an audience. Whalemen did not think of chanteys as songs—they were simply a means to ease the burden of work. The popularity of a sea chantey was its versatility in making the workaday process flow more smoothly. It was said that a good chantey was as good as ten men, whether raising the anchor, hoisting the sail or cutting-in the whale.

"Like the sailors who sang them, sea chanteys traveled from ship to ship for years before they were written down."[130] With the publication of Huntington's landmark book in 1964, the songs of the whalemen were captured for posterity. *Songs the Whalemen Sang*, republished in 2012, "remains a landmark work, preserving the melodies of a bygone era and also giving insight into the lives of the whalemen of the 1700s and 1800s," wrote Mark Lovewell for the *Vineyard Gazette*.

Whaling chanteys represent a historical interlude, a unique musical form that originated in the whaling industry, memorialized by folk singers today. "Vineyard men brought home songs from all the voyages they sailed—there were always singers in every forecastle and every cabin—and there was always exchange of song."[131] Before compact discs or phonographs, before radio or television, whalemen sang songs aboard ship and shared their songs whenever and wherever they sailed around the world. Chanteys have become part of the heritage of the whaling industry.

In the nineteenth century, whaleships from New England sailed virtually all the oceans of the world. Whalemen hailing from New Bedford, Nantucket and Martha's Vineyard brought their songs with them, and those chanteys promoted the maritime heritage as much "as the old white clapboard homes of the whaling captains that stand on North Water street in Edgartown, or the scrimshaw that resides on museum shelves."[132]

For more than two hundred years, whaling provided a successful career for New Englanders. Many of the finest sea captains and sailors called New England home, and their ships were the most reliable on the seas. "Pride of seamanship and love of the sea helped convince many to undertake the long voyages—often of four years or more—that were required to reach the north Pacific whaling grounds, fill their holds with oil, and return."[133] The waters of Vineyard Sound became a melting pot, a place where cultures

Baleen was carved for decorative cane handles. *Courtesy of the New Bedford Whaling Museum; photo by Thomas Dresser.*

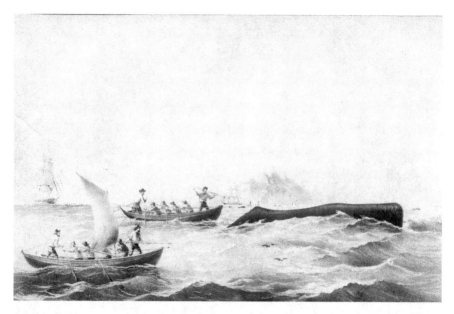

Art by a whaleman aboard the *Iris* captured the drama and danger of a whaling voyage. *Courtesy of the Martha's Vineyard Museum.*

passed, heading north or south through the sound, a waterway busier than anywhere but the English Channel. And the songs the whalemen sang united whalemen in their common task. Singing proved an inspiration for their work and was shared worldwide.

Scrimshaw is carving or etching on whale teeth or whalebone. Designs or words were carved with a penknife or needle, and the design was rubbed with soot or oil to accentuate the etching. Often the designs were whaleships, simple sketches or portraits. Scrimshaw served as gifts for loved ones on the return of a whaling mission.

Scrimshaw evolved into an art. Whalemen had time on their hands. Whalebone was lying around. It was an easy and enjoyable task to carve an image on a section of baleen, the sieve-like apparatus in bowhead whales' mouths, or on whalebone or even the tooth of a whale.

Scrimshaw etchings became quite popular. Whalemen skillfully designed pie crimpers with a wheel to run around the edge of a pie. They created handles for canes and umbrellas out of whalebone. Elaborate folding reels were designed to hold the equivalent of a skein of yarn.

And when whalemen encountered walruses in the Arctic, they often killed them for their blubber, which they boiled down just like whale oil for use as an illuminant. Once the whalemen plundered the blubber, the ivory tusks served as a palette for etchings.

In *Moby-Dick*, Melville describes scrimshaw as "lively sketches of Whales and Whaling scenes, graven by the fishermen themselves on Sperm Whale teeth or ladies' busks wrought out of the Right Whale bone and other Scrimshander articles."[134]

Absence from home for long periods of time meant seamen were eager to meet one another, and a visit was often in order. When one whaleship greeted another on the high seas, they "spoke," or gathered to meet. Such a visit was a gam—an unplanned social event far from home. The word *gam* initially referred to a herd or school of whales but evolved into a term for the meeting between whaleships.

Again, we reference *Moby-Dick*: "Gam. Noun. A social meeting of two (or more) whaleships generally on a cruising ground."[135]

Whaleboats were lowered to transfer the captain from one ship to another. Often, crewmen would visit as well, for most whalemen from New England communities knew one another or had some connections. The crew aboard a ship that had been at sea for years eagerly sought news from home. In turn, the captain of the second ship could share where he found the best whaling grounds. Whaling was less competitive than most commercial enterprises. The goal was to capture as many whales as possible, not to hinder another whaleship.

News was exchanged. Chitchat would ensue. The gam might last a day or two or even a week, depending on how urgent each captain was to pursue his venture. Gale Huntington explained that a gam was basically a social visit among the captains and crew of two or more whaleships. The ships would be hove to, either moored or secured together, and the crew could visit back and forth, exchanging adventures, updating news

A captain's wife would be lowered into a whaleboat via a gamming chair designed for such a purpose. *Courtesy of Mystic Seaport; Photo by Joyce Dresser.*

and gossip and passing along mail. Huntington noted sailors would often exchange songs in a gam.

When wives were aboard ship, they would want to visit as well. The visiting wife was rowed across to the other whaleship, raised in their gamming chair, and a conversation ensued between the two whaling wives.

A journal entry of a gam from May 4, 1842, reads: "Strong trades spoke ship Achanet [*Acushnet*] of F Haven got letters so ends."[136] The captain of the ship *Columbus* was Tristram Daggett Pease, younger brother of the *Acushnet* captain Valentine Pease. The two brothers met on the high seas. And Herman Melville was aboard the *Acushnet* at the time.

Dozens of whaleships gathered at Maui in the Sandwich Islands (Hawaii). At one gam were two barks from the Vineyard, four from Nantucket and thirty-five whaleships from New Bedford. Another gam occurred when the captains of the *Navigator* and the *Splendid*, both from Edgartown, met aboard ship.

Henry Beetle Hough noted that "Jared Jernegan, now captain of the *Roman*, and his brother Nathan, now commanding the *Splendid*, met in the South Pacific. It was the first time they'd seen each other in seventeen years."[137] Hough also reported William Cleaveland, of the *Morning Star*, met his brother, Captain Jacob Cleaveland, of the *Julian*, in the Galapagos, for the first time in eighteen years.

Another gam took place when three whaling wives from Martha's Vineyard enjoyed tea at a hotel while moored in the Galapagos Islands. Mary Carlin Cleaveland from the *Seconet*, Mrs. John Oliver Norton of *Morning Light* and Charlotte Jernegan of the *Niger* shared Vineyard memories far from home. Often, whaling captains brought their ships into St. Paul's Island in the Indian Ocean hoping to meet a friend from home. Following a gam with fellow Edgartown captains, Shubael Norton commented, "We had a first rate time."

As previously noted, heaving the log was the expression used to measure the speed of a ship by tossing a float into the water and counting how fast a knotted string fed out as an hourglass ran down. Heaving the log evolved into keeping the log, maintaining the official record of the whaleship. The keeper of the log was the mate or captain who documented the vagaries of a whaling voyage, recording the weather, location, whales sighted and captured and unusual activities such as "speaking" with a fellow whaleship.

Logbooks "tended for the most part to be perfunctory, dedicated to recording the necessary but tedious evolutions of shipboard life."[138] Henry Beetle Hough observed that reading through logbooks was not very elucidating. Much of the writing was perfunctory, repetitive and did not reveal much of what actually occurred aboard ship. In another context, however, Hough noted, "When a whaling captain's voice may really be heard, therefore, telling what he did, where he went, what he observed, there is a rare opportunity to catch history in the act."[139]

Not only was it customary, but also owners and governing offices expected each whaleship would maintain a logbook detailing when and where whales were sighted, chased and caught, describing shipwrecks, ships seen or visited, weather conditions and wind direction. Unfortunately, the

majority of these logbooks have been lost over the years to water damage, discarded or simply misplaced. After a voyage was completed, it was rare to protect or preserve these books.

The Martha's Vineyard Museum has more than one hundred whaling logbooks in its archives. Five of their logbooks have been digitized, a preservation form conducted by the Northeast Document Conservation Center (NEDCC). Logs belonging to the *Iris, Erie, Rose Pool, Independence* and the *Adeline Gibbs* are now preserved in perpetuity. The five volumes suffered various injuries, such as pages torn or ripped, fading ink and water damage; now they are universally accessible. The goal is to digitize the entire logbook collection.

Bonnie Stacey, curator of the Martha's Vineyard Museum, acknowledges many logbooks were lost or destroyed over the years by people who failed to recognize their importance. Other uses were made of the logbooks, or they were considered of no value. Today, we treasure these artifacts as reference points of a bygone era.

It is a challenge to protect logbooks for future research. Often, the books even served another purpose. When perusing the log of the whaleship *Sharon*, involved in the mutiny of 1842, the son of the slain Captain Howes Norris kept personal records in the blank pages of the log, noting letters he sent or received and towns he visited. Fortunately, the bulk of the log is intact, although the pages just prior to the violent mutiny were cut out, destroying an important piece of history.

Making whaling logbooks accessible to a wider audience is a commendable goal of museums and archival vaults. Museums, such as the Providence Public Library (the Nicholson Collection), New Bedford Whaling Museum and Mystic Seaport are repositories for these valuable archives of our whaling past.

The largest collection of logbooks and journals is at the Providence Public Library. Jordan Goffin, the head curator of collections, confirmed that in the Nicholson Collection, "We currently have 797 logbook and journal volumes, which account for a total of 1,217 records of voyages [some logbooks include more than one voyage, and sometimes more than one vessel]."[140] Virtually all logbooks are available online at http://www.provlib.org/whaling-logbooks.

Scanning pages of various logs, one is drawn to the whale stamps, which indicate the type of whale captured and number of barrels of oil obtained. One might consider these whale stamps primitive folk art, although they have a professional style. At the time, it was routine to keep the log to document the type of whale and barrels of oil obtained. On several logbooks, sketches

Stamps were used to identify whales or ships the whaleships encountered. The stamps accented logbook pages. *From Stuart Sherman's* The Voice of the Whaleman.

or drawings preserve memories of an adventure far from home and long ago, important to the person involved. This links the whaleship log to a personal connection with events, often a dramatic outcome we may only learn about by chance. Reading a logbook is an opportunity to connect with that captain or mate from years gone by.

An additional asset in reviewing whaleship logs is an understanding of what the weather was like all those years ago. The National Oceanic

and Atmospheric Administration (NOAA) initiated a program called Old Weather: Whaling. This utilizes Arctic weather records from logbooks housed at the Martha's Vineyard Museum, New Bedford Whaling Museum and the Providence Public Library, among other sites, to draw conclusions about historical weather patterns. It is akin to an archaeological dig, divining what the weather was like long ago. And this proved helpful in uncovering the whaleships lost in the Arctic freeze. Delving into the logbooks can be a fount of information about climate change traced over time. Old Weather: Whaling uses the past to predict the future.

Richard Shute was a photographer in post–Civil War Edgartown. His photographic process evolved from daguerreotypes to glass plates to paper prints, major improvements in his working process. Shute created stereoscopic views to promote his photographs, which became popular in the late 1860s.

A stereoscopic viewfinder held a card with two identical images. The individual holds the viewfinder up to the face. Because our eyes are inches apart, that distance creates perspective in the picture. It is a simple but effective way to appreciate depth in an image.

Shute photographed Edgartown, the Wesleyan Grove Campground in Oak Bluffs and Holmes Hole and sold collections of images in stereoscopic cards. And Shute was intrigued with whaling.

Richard Shute created a series of a dozen stereoscopic scenes to describe whaling. In 1868, Shute constructed a tabletop diorama complete with a lifelike model of a whaling ship. He then added imagined scenes from whaling adventures and photographed the scenes, which included chasing and striking whales, harpooning a whale and a whale upsetting a whaleboat.

The stereoscopic scenes were educational. Cutting-in a dead whale was explicit. One of Shute's diorama scenes shows the blanket pieces of blubber hoisted aboard ship, known as "scarfing." "Junk" was the head of the whale filled with spermaceti used for candles and ointments. "Cracklings" were chunks of fried blubber tossed in the tryworks as fuel. Viewers learned about whaling through Shute's images.

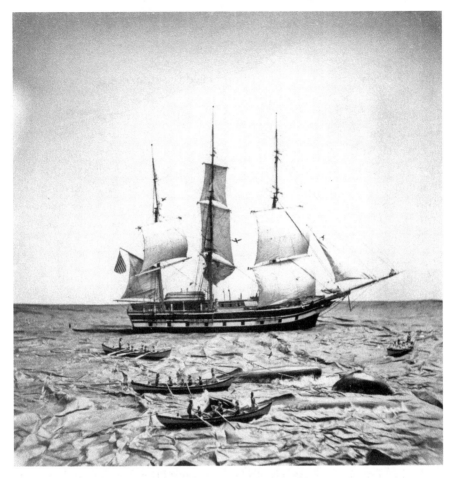

Shute's stereoscopic scenes paired two pictures in a viewfinder to give perspective to an image. *Courtesy of the Martha's Vineyard Museum.*

"Whaling should be remembered because it led to the growing up of new seas and the discovery of new islands, because it widened our natural horizons." Another perspective on whaling is that "the part it played in our history was small, but it was fraught with drama and romance."[141] The twelve images Shute created were popular in that they brought an imagined whaleship enterprise into the living rooms of curious viewers. Stereoscopic scenes were one of the few ways people could witness the whaling experience without being part of it.

151

Moby-Dick epitomized whaling and propelled the romance and drama of a whaleship into the American psyche.

Herman Melville made a name for himself with two South Sea novels written in the 1840s, *Typee* and *Omoo*, which brought him great prominence as a writer with a skilled ear. His 1851 novel about the whaling industry, *Moby-Dick*, failed with critics and in bookstores. Readers disliked the evil character of Captain Ahab. They overlooked the linguistic alliteration and missed the historical references. Critics did not know what to make of a six-hundred-page tome that seemed to go nowhere and everywhere at once.

And yet it's a great read. Informative, amusing, dramatic, spiritual, historical and psychological, *Moby-Dick* casts a wide net across the world of whaling. As noted, it seems drawn from the drama of the whaleship *Essex*, sunk by a whale in 1820, and by the mutiny aboard the *Sharon* in 1842. Obvious comparisons have been drawn to Melville's own experience aboard the *Acushnet* under the very real Captain Valentine Pease of Edgartown. Examples of actual experiences are evident throughout the novel.

As a piece in the *New York Times* observed, "[T]he whaling industry had driven an early phase of American industrialization and imperialism. Whaling was the United States' first foray into global natural resource extraction, and it had awakened a demand for fuel that still shapes our decisions about energy, economics and environmental responsibility today."[142] *Moby-Dick* epitomized that historical drama.

Yet the book did not attain bestseller status until Ray Weaver published his biography of Melville in 1921, entitled *Herman Melville: Mariner and Mystic*. Once critics praised Weaver's book, *Moby-Dick* became a classic.

Whaling was a barbaric enterprise, killing peaceable leviathans for their oil to light our tables. For all its barbarism, whaling was still considered a necessity by a population on the cusp of the Industrial Revolution. The virtues and values of whale oil dominated economic needs at the time. Just as we rationalize why we raise and kill cattle today to replenish the food on our tables, so the capturing and killing of whales was considered just and appropriate a century or two ago. The situation changes, but man still dominates his surroundings.

Author Nathaniel Philbrick commented in the introduction to *Moby-Dick*: "I had been unexpectedly prepared to appreciate the dirty, often brutal conditions aboard a whaleship: floating factories dedicated to ripping

blubber from the whale's corpse, chopping the blubber up, then boiling it into oil amid a stinking pall of sooty smoke." That was the unpleasant side of the industry.

Philbrick continued, discovering another level of appreciation for the novel: "*Moby-Dick* may be, on occasion, mythic and metaphysical, but it is also an extraordinarily detailed and accurate account of American whaling in the nineteenth century. As Ishmael insists, again and again, he is not making this up."[143] Melville described the essence of whaling in *Moby-Dick*, even as he incorporated the "mythic and metaphysical." It's quite a tale.

There is also a Vineyard connection with the author and former whaleman. "What most people do not know is that in 1908 Melville's daughter Frances Melville Thomas and her husband Henry B. Thomas, purchased this house."[144] "This house" refers to 80 South Water Street, Edgartown.

Captain Valentine Pease built his house at 80 South Water Street early in the nineteenth century. The house became known as the *Moby-Dick* house, as Pease served as the prototype for Melville's Captain Ahab. The house attained further fame as the summer home of nationally acclaimed actress Patricia Neal. From 1979 until her death in 2010, the actress called her home *Moby-Neal*.

And it is because of *Moby-Dick* that the reputation of Valentine Pease has been a challenge to acknowledge:

> *Descendants of the Pease family here have always been uncomfortable over the relationship between the true Valentine Pease and the fictional Captain Ahab. Who would want to be a descendant of so mean-spirited a fellow? In town, Captain Pease was widely known as a fine old man, a gardener, a local statesman in town, referred to as "Uncle Val" on the waterfront.*[145]

The log of the *Acushnet* has never surfaced, unfortunately, and there is very little documentation to refute or confirm the behavior of Captain Valentine Pease.

Captain Valentine Pease was born near Caleb's Pond on Chappaquiddick in 1797.

Henry Beetle Hough was awed by the number of whaling masters born on Chappaquiddick: "Chappaquiddick seems to have existed for the sole purpose of breeding whalemen. There is extant a list of 44 masters, 12 of whom were Peases who were born and raised on the Island in the principal era of whaling."

Pease was captain of the *Planter*, from Edgartown, condemned in 1830. His most famous role, obviously, was as captain of the *Acushnet*, out of Fairhaven, which sailed from 1841 to 1845. Herman Melville was a green-hand aboard the *Acushnet* and learned the whaling trade during his stint aboard ship, which apparently was instructive but not placid. Melville was one of the crew who complained at the U.S. Consul in Patia, Peru, of tyrannical and inhuman treatment by Captain Pease. Melville later deserted the ship with a shipmate, Tobias Greene.

Other than as captain of the *Acushnet*, Valentine Pease played a subservient role in the history of Edgartown whaling captains.

Pease, euphemistically known as "Uncle Val," lived out his retirement in Edgartown.

EPILOGUE

People often enjoy visiting sites that recall the halcyon days of whaling. The New Bedford Whaling Museum houses an extensive collection of accessible material ranging from whale skeletons to whaleboats to harpoons to whaling paintings. The adjacent National Park Visitor Center has a smaller display. The most extensive collection of logbooks is preserved in the Nicholson Collection of the Providence Public Library, well documented by Stuart Sherman's *The Voice of the Whaleman* and extensively expanded online today. And the Nantucket Whaling Museum offers an opportunity to view whaling artifacts.

Mystic Seaport is the go-to site to appreciate a seaside whaling community, with shops and stores and museum memorabilia, as well as the noble *Charles W. Morgan*. Albert Church wrote of the *Morgan* in 1938, "[A]lthough I was part owner I never saw her until she returned to her home port of New Bedford after twenty years' operation out of San Francisco in the Arctic and Northern Pacific fishery."[146] The *Morgan* has been completely refurbished and sailed on its thirty-eighth voyage in the summer of 2014. Today it rests comfortably in the waters of Mystic Seaport.

The Martha's Vineyard Museum is ripe with whaling artifacts, from logbooks to letters to paintings and whaling implements and a knowledgeable staff eager to assist in research of the whaling industry.

The Martha's Vineyard Preservation Trust has developed a historical program in the old Carnegie Library on North Water Street, Edgartown. Themes of the program include island beginnings, economic impact,

building community and the importance of restoration and adaptive reuse of significant island landmarks to contemporary island life. Whaling fits neatly and clearly into this historic panorama.

Displays interpret the impact of the whaling era on the Vineyard. The new center houses an area specifically devoted to whaling, including a harpoon, a trypot, scrimshaw and a whaleboat model. Hand-painted images depicting whaling life and relevant whaling documents reprise the historic past of Martha's Vineyard in a readily accessible context.

This exhibit is well worth a visit.

Years ago, people were intrigued by the whaling industry. In his retirement in the 1920s, Captain George Fred Tilton served as a tour guide of the last existing wooden whaleship, the *Charles W. Morgan*. He observed,

> *Perhaps we two, the ship and myself, compare pretty favourable. She is considerably older than I am, being eighty-seven years off the stocks, but both of us have been tumbled around by the waters of every ocean, and now that we are not wanted to hunt whales any more, we are laid up here so that people can get some idea of how the business used to be done. The ship is on exhibition, and I sometimes think that I am too.*[147]

Capt'n George Fred is Tilton's 1969 amusing and informative autobiography. While whaling initially offered ambitious young men a chance to make a living, it gradually declined into a dying industry.

> *The late Marcus W. Jernegan, himself the son of a whaling master and one of the few authorities who could speak of whaling both from first hand knowledge and scholarship, liked to tell how he met two captains at an Island affair. "Do you realize," Captain West said to him, "that I am the last of the sperm whalers?" and a few minutes later, Capt. H.H. Bodfish happened along and remarked, "Do you realize that I am the last surviving shipmaster of bowhead whaling?"*[148]

These icons of the whaling industry were fading from center stage.

Ellsworth West's obituary in 1949 paid tribute to his own life, as well as the whaling industry:

> *It is a sad thing to contemplate the passing of the last whaling captain of Martha's Vineyard. Some whalemen still survive, but with the death of Capt. Ellsworth L. West of Chilmark, the list of whaling masters is*

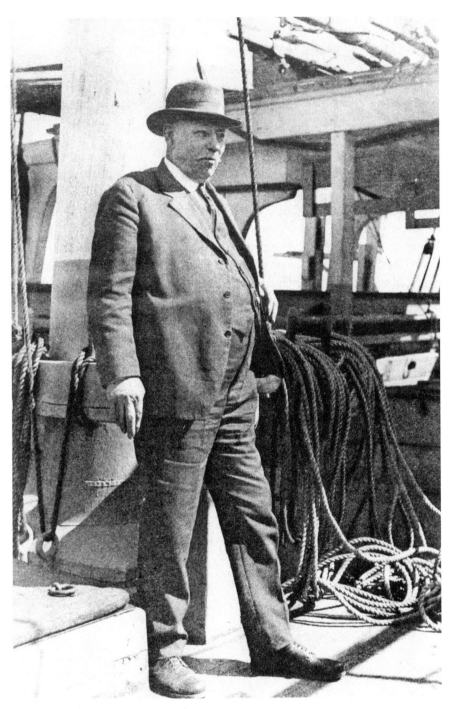

Whaleman George Fred Tilton retired to work as a tour guide aboard the *Charles W. Morgan* in the 1920s. *Courtesy of the Martha's Vineyard Museum.*

closed. The industry has long been gone and can never come again, and as we miss Captain West from the Island scene, we are cut off from that salty, proud and brave past which meant so much.

It is of note that a coffee company, founded in 1970, assumed the name of the first mate aboard the *Pequod*. Captain Ahab's first mate was named Starbuck. Who has not heard of Starbucks Coffee?

On another note, "With regret we now consider her deceased," reported researcher Ken Balcomb on the suspected demise of a century-old whale nicknamed Granny. "She was typically seen at the head of one of three family groups of whales that travel with their mothers or grandmothers."[149]

Today, whales are a protected species almost worldwide. The International Whaling Commission (IWC) promulgated regulations to conserve whale stocks in 1946. Only Norway, Japan and Iceland still kill whales in the face of the 1986 ban on commercial whaling. The days of blubber hunting are treasured and preserved in our history books and museums.

NOTES

Chapter 1

1. Melville, *Moby-Dick*, 118.
2. Shirley Mayhew, "Decline of the American Whale Fisher: 1865–1900," *Dukes County Intelligencer*, August 1964.
3. Stackpole, *Sea-Hunters*, 22–23.
4. Starbuck, *History*, 17.
5. Banks, *History*, vol. 1, 432.
6. Braginton-Smith and Oliver, *Cape Cod Shore Whaling*, 68.
7. Starbuck, *History*, 36.
8. Stackpole, *Sea-Hunters*, 450.
9. Starbuck, *History*, 51.
10. Ibid., 42.
11. Druett, *Petticoat Whalers*, 89.
12. Hough and Whiting, *Whaling Wives*, 80.

Chapter 2

13. Stackpole, *Sea-Hunters*, 92.
14. McGuane, *Hunted Whale*, 146.
15. Gibson, *Demons of the Waters*, 19–20.
16. Stackpole, *Sea-Hunters*, 85.

17. Ibid., 134.
18. Starbuck, *History*, 85.
19. Thomas Jefferson, "Report of the Secretary of State, on the Subject of the Cod and Whale Fisheries, Made Conformably to an Order of the House of Representatives," www.gilderlehrman.org/collections/27ecfe2f-0f54-4b16-a29b-834193652380.
20. Stackpole, *Sea-Hunters*, 22–23.
21. Lund, *Whaling Masters*, viii.
22. Hough and Whiting, *Whaling Wives*, 75.

Chapter 3

23. Acton, *Whaling Captain's Life*, 14.
24. Ibid., 9.
25. Ibid., 23.
26. Hough, *Great Days of Whaling*, 13.
27. Acton, *Whaling Captain's Life*, 26.
28. "Whaleman Burridge of the Steam Bark Bow Head Tells His Story," *Dukes County Intelligencer*, May 1988.
29. Church, *Whale Ships and Whaling*, 31.
30. McGuane, *Hunted Whale*, 30.
31. West, *Captain's Papers*, 13.
32. Dunlop, *Chappy Ferry Book*, 19.

Chapter 4

33. Songini, *Lost Fleet*, 30.
34. Braginton-Smith and Oliver, *Cape Cod Shore Whaling*, 37.
35. Melville, *Moby-Dick*, 104–5.
36. Hough, *Great Days of Whaling*, 110.
37. *Vineyard Gazette*, June 20, 2014.
38. Ibid.
39. Hough, *Great Days of Whaling*, 145.
40. Sherman, *Voice of the Whaleman*, 31.
41. Ibid., 36.

Chapter 5

42. Huntington, *Songs the Whalemen Sang*, xv.
43. Stackpole, *Sea-Hunters*, 450.
44. Tilton, *Capt'n George Fred*, 287.
45. Melville, *Moby-Dick*, 130.
46. Shoemaker, *Native American Whalemen*, 28.
47. New Bedford Whaling Museum, https://www.whalingmuseum.org.
48. "Amos Smalley, 1877–1961," Tomahawk Charters, http://www.tomahawkcharters.com/amos.html.
49. *Gazette Chronicle*, January 7, 2010.
50. *Vineyard Gazette*, January 13, 2017.
51. Railton, *History of Martha's Vineyard*, 142.
52. Sturgis Library summary.
53. Gibson, *Demons of the Waters*, 53.
54. Melville, *Moby-Dick*, 84.

Chapter 6

55. Railton, *History of Martha's Vineyard*, 139–42.
56. Gibson, *Demons of the Waters*, 53.
57. Stackpole, *Sea-Hunters*, 270.
58. Tilton, *Capt'n George Fred*, 47.
59. Bockstoce, *Whales, Ice and Men*, 260.
60. Hough and Whiting, *Whaling Wives*, 32.
61. Lloyd Hare, "Whaling Captins and Fabulous Frisco," *Dukes County Intelligencer*, February 1960.
62. West, *Captain's Papers*, 160.
63. Adam Moore, "The Life of a Tree: The Quansoo Oak," *MV Times*, March 9, 2016, http://www.mvtimes.com/2016/03/09/life-tree-quansoo-oak.
64. Tilton, *Capt'n George Fred*, 90.
65. *MV Magazine*, May 1, 2014.

Chapter 7

66. Church, *Whale Ships and Whaling*, 17.
67. Railton, *History of Martha's Vineyard*, 139–42.
68. Church, *Whale Ships and Whaling*, 44.

Chapter 8

69. *Vineyard Gazette*, 1895.
70. Provided by Timothy Ward, great-grandson of Samuel Osborn Jr.
71. Hough and Whiting, *Whaling Wives*, 287.
72. *MV Magazine* (Winter-Spring 2016–17).
73. "Death of Samuel Osborne Jr.," *Vineyard Gazette*, https://vineyardgazette.com/news/1895/03/21/death-samuel-osborn-jr.

Chapter 9

74. Hough and Whiting, *Whaling Wives*, 93.
75. Norling, *Captain Ahab*, 229.
76. Druett, *Petticoat Whalers*, 154.
77. Riggs and Riggs, *From Off Island*, 50.
78. Hough and Whiting, *Whaling Wives*, 217–18.
79. Tilton, *Capt'n George Fred*, 101.
80. Hough and Whiting, *Whaling Wives*, 252.

Chapter 10

81. Songini, *Lost Fleet*, 125. Quote by officer William Whittle of the *Shenandoah*.
82. *New York Times*, January 26, 2012.
83. Songini, *Lost Fleet*, 126.
84. Hough, *Great Days of Whaling*, 98.
85. Songini, *Lost Fleet*, 168.
86. Ibid., 202.
87. Ibid., 247.
88. Ibid., 269.

89. Hough, *Great Days of Whaling*, 120.

90. Songini, *Lost Fleet*, 243.

Chapter 11

91. *Vineyard Gazette*, August 13, 1982.

92. West, *Captain's Papers*, 72.

93. Starbuck, *History*, 56.

94. Riggs and Riggs, *From Off Island*, 159–60.

95. Hohman, *American Whaleman*, 308.

96. West, *Captain's Papers*, 58.

97. Gibson, *Demons of the Waters*, 17.

98. Ibid., 71.

99. Ibid., 108.

100. Druett, *Wake of Madness*, 21.

101. Ibid., 116.

102. Ibid., 155.

103. Ibid., 229.

104. Starbuck, *History*, 377.

Chapter 12

105. Tilton, *Capt'n George Fred*, 171.

106. Church, *Whale Ships and Whaling*, 37.

107. West, *Captain's Papers*, 41.

108. Songini, *Lost Fleet*, 311.

109. Ibid., 317.

110. Ibid., 327.

111. Ibid., 329.

112. Ibid., 333.

113. *Vineyard Gazette*, July 5, 1996; reprint from November 10, 1871.

114. Railton, *History of Martha's Vineyard*, 335–36.

115. Ibid., 286–87.

116. *Vineyard Gazette*, December 11, 1874.

117. "Search for the Lost Whaling Fleets of the Western Arctic," National Marine Sanctuaries, https://sanctuaries.noaa.gov/shipwrecks/lost-arctic-whaling-fleet.

118. Tilton, *Capt'n George Fred*, 186.

119. Ibid., 190.

120. *Vineyard Gazette*, January 15, 1903.

121. Arthur Railton, "Shipwrecked 525 Miles from the North Pole with Captain Coffin of Edgartown," *Dukes County Intelligencer*, August 1998.

122. Ibid. The North Pole is 90 degrees.

123. James Fulton, "Final Voyage of the Bark *Bow Head*," *Dukes County Intelligencer*, May 1988.

Chapter 13

124. Huntington, *Songs the Whalemen Sang*, 1.

125. Railton, *History of Martha' Vineyard*, 139–42.

126. Dresser, *Music of Martha's Vineyard*, 20.

127. Huntington, *Songs the Whalemen Sang*, xvii.

128. Huntington, *Gam*, xi.

129. Ibid., 213.

130. Dresser, *Music of Martha's Vineyard*, 20.

131. Huntington, *Folksongs*, 8.

132. *Vineyard Gazette*, January 5, 2006.

133. Huntington, *Gam*, 1.

134. Melville, *Moby-Dick*, 15.

135. *Falmouth Enterprise*, August 6, 1954.

136. Sherman, *Voice of the Whaleman*, 24.

137. Hough and Whiting, *Whaling Wives*, 118.

138. Gibson, *Demons of the Waters*, 7.

139. Hough, Intro to *Captain's Papers*, viii.

140. Jordan Goffin, e-mail communication, March 1, 2017.

141. Dulles, *Lowered Boats*, 9–10.

142. Jamie L. Jones, "The Navy's Stone Fleet," *New York Times*, January 26, 2012, http://opinionator.blogs.nytimes.com/2012/01/26/the-navys-stone-fleet/?_r=0.

143. Philbrick, introduction to *Moby-Dick*, by Herman Melville, iv-v.

144. *Vineyard Gazette*, April 23, 2014.

145. Mark Lovewell, "Herman Melville on Martha's Vineyard: Island Played Role in Great Literary Work," http://markalanlovewell.com/writer/herman-melville.html.

Epilogue

146. Church, *Whale Ships and Whaling*, 9.

147. Tilton, *Capt'n George Fred*, 293.

148. *Vineyard Gazette*, April 15, 1949 (repeated by Hilary Wall in the *Vineyard Chronicle*).

149. *Boston Globe*, January 4, 2017.

BIBLIOGRAPHY

Acton, Henry. *A Whaling Captain's Life: The Exciting True Account by Henry Acton for His Son, William*. Charleston, SC: The History Press, 2008.

Banks, Charles. *The History of Martha's Vineyard*. 3 vols. Edgartown, MA: Dukes County Historical Society, 1966.

Bockstoce, John. *Whales, Ice and Men*. Seattle: University of Washington Press, 1995.

Braginton-Smith, John, and Duncan Oliver. *Cape Cod Shore Whaling: America's First Whalemen*. Charleston, SC: The History Press, 2008.

Church, Albert Cook. *Whale Ships and Whaling*. New York: W.W. Norton & Company, 1938.

Cornell, E.C. *Eighty Years Ashore and Afloat, or the Thrilling Adventures of Uncle Jethro*. Boston: Andrew Graves, 1873.

Dolin, Eric. *Leviathan: The History of Whaling in America*. New York: W.W. Norton & Company, 2007.

Dow, George. *Whale Ships and Whaling*. New York: Argosy Antiquarian, 1967.

Dresser, Thomas. *Music on Martha's Vineyard*. Charleston, SC: The History Press, 2014.

Druett, Joan. *Petticoat Whalers: Whaling Wives at Sea, 1820–1920*. New Zealand: Harper Collins, 1991.

Druett, Judy. *In the Wake of Madness*. Chapel Hill, NC: Algonquin Books, 2004.

Dulles, F.R. *Lowered Boats*. Boston: Harcourt Brace, 1933.

Dunlop, Tom. *The Chappy Ferry Book*. Edgartown, MA: Vineyard Stories, 2012.

Gibson, Gregory. *Demons of the Waters: The True Story of the Mutiny on the Whaleship* Globe. Boston: Little Brown, 2002.

Hohman, Elmo. *The American Whaleman.* New York: Longmans, Green, 1928.

Hough, Henry Beetle. *The Great Days of Whaling.* Boston: Houghton Mifflin, 1958.

Hough, Henry Beetle, and Emma Mayhew Whiting. *Whaling Wives of Martha's Vineyard.* Boston: Riverside Press, 1953.

Huntington, Gale. *Folksongs from Martha's Vineyard.* Orono, ME: Northeast Folklore Society, 1966.

———. *The Gam: More Songs the Whalemen Sang.* Northfild, MN: Loomis House Press, 2014.

———. *Songs the Whalemen Sang.* Barre, MA: Barre Publishers, 1964.

Lund, Judith. *Whaling Masters and Whaling Voyages Sailing from American Ports.* Sharon, MA: New Bedford Whaling Museum, Kendall Whaling Museum and Ten Pound Island Books, 2001.

McGuane, James. *The Hunted Whale.* New York: W.W. Norton & Company, 2013.

Melville, Herman. *Moby-Dick.* London: Penguin, 2001.

Nichols, Peter. *Final Voyage.* New York: Penguin Books, 2009.

Norling, Lisa. *Captain Ahab Had a Wife.* Chapel Hill: University of North Carolina Press, 2000.

Railton, Arthur. *The History of Martha's Vineyard.* Beverly, MA: Commonwealth Editions and Martha's Vineyard Historical Society, 2006.

Riggs, Dionis Coffin, and Sidney Noyes Riggs. *From Off Island.* New York: McGraw-Hill, 1993.

Sherman, Stuart. *The Voice of the Whaleman.* Providence, RI: Providence Public Library, 1965.

Shoemaker, Nancy. *Native American Whalemen and the World.* Chapel Hill, NC: UNC Press, 2015.

Songini, Marc. *The Lost Fleet: A Yankee Whaler's Struggle Against the Confederate Navy and Arctic Disaster.* New York: St. Martin's Press, 2007.

Sperus, John. *The Story of New England Whales.* New York: MacMillan, 1908.

Stackpole, Edouard. *The Sea-Hunters: The New England Whalemen During Two Centuries 1635–1835.* New York: J.B. Lippincott & Company, 1953.

Starbuck, Alexander. *The History of the American Whale Fishery.* New York: Argosy-Antiquarian, 1964.

Tilton, George Fred. *Capt'n George Fred.* New York: Doubleday, Doran & Company, 1969.

West, Ellsworth Luce. *Captain's Papers.* Barre, MA: Barre Publishers, 1965.

BIBLIOGRAPHY

Periodicals

Dukes County Intelligencer
Hyperallergic Magazine
Martha's Vineyard Magazine
Vineyard Gazette

INDEX

ABOUT THE AUTHOR

This is my tenth book on Vineyard history published by The History Press over the last decade. Some might say I've found my niche; others feel I've gone as far as I can go. Whatever the case, it's been a good run, rewarding, inspiring and memorable. Now that I have turned seventy, I enjoy the opportunities afforded by retirement. Life is an inspiration. I look forward to each day with enthusiasm: eager to exercise, socialize and write whatever is on the docket for the day. It's an enjoyable time, especially sharing my days with Joyce, my wife of twenty years. For more information, visit thomasdresser.com.

Also by Thomas Dresser, published by The History Press:

Mystery on the Vineyard (2008)
Africans Americans of Martha's Vineyard (2010)
The Wampanoag Tribe of Martha's Vineyard (2011)
Disaster off Martha's Vineyard (2012)
Women of Martha's Vineyard (2013)
Martha's Vineyard in World War II (2014)
Music on Martha's Vineyard (2014)
Martha's Vineyard: A History (2015)
Hidden History of Martha's Vineyard (2017)

CPSIA information can be obtained
at www.ICGtesting.com
Printed in the USA
LVHW082300180119
604490LV00007B/11/P